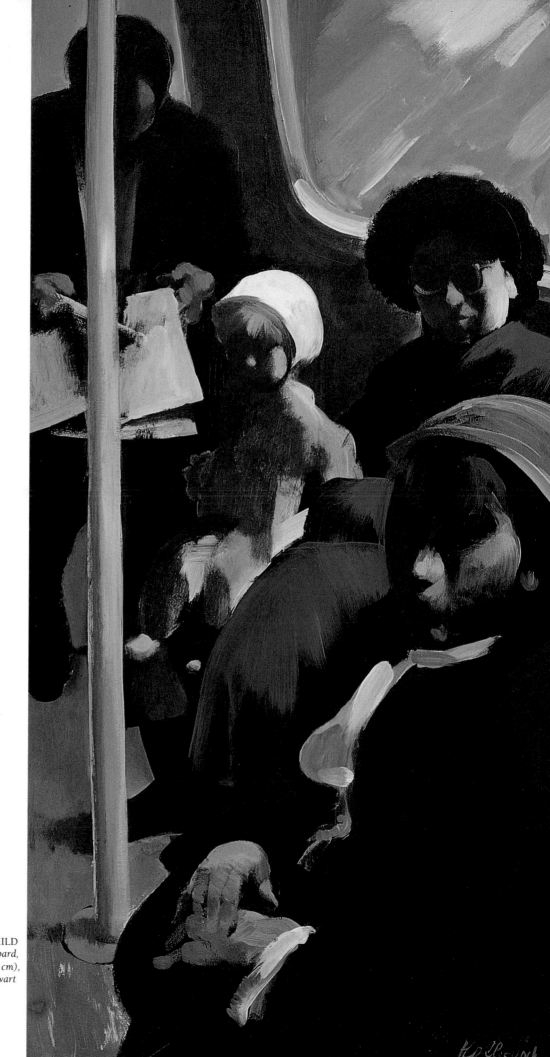

BUS RIDERS WITH CHILD
acrylic on illustration board,
40″ × 20″ (101.6 cm × 50.8 cm),
collection of Mrs. Gayla Stewart

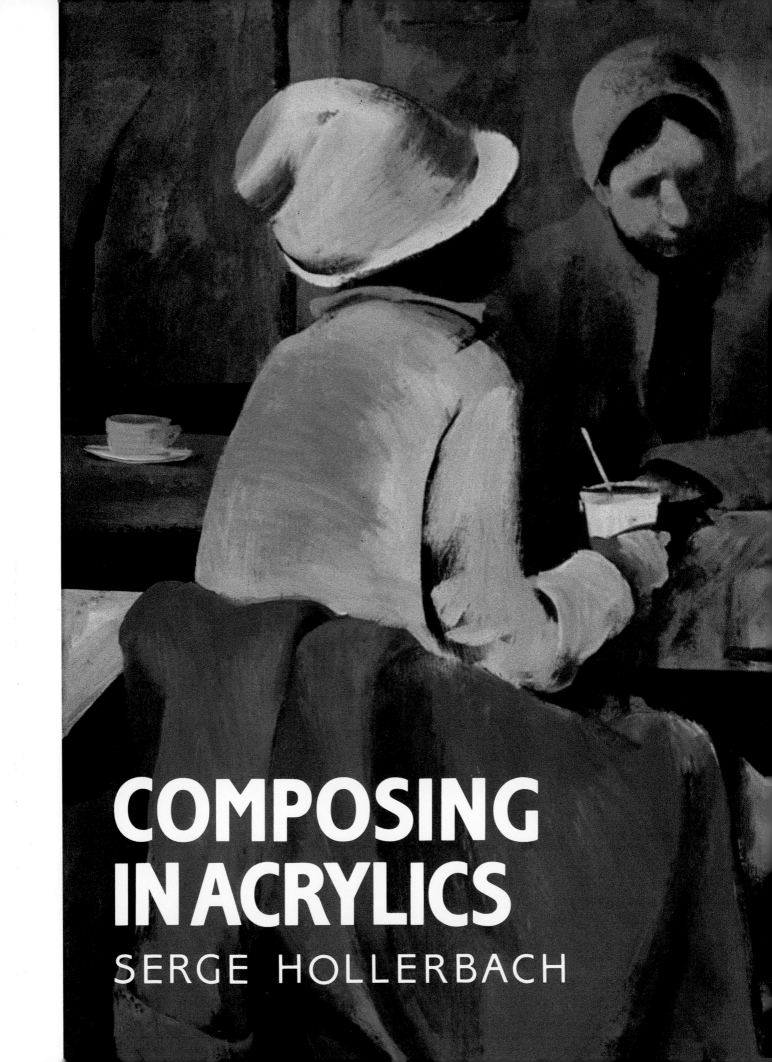

COMPOSING
IN ACRYLICS

SERGE HOLLERBACH

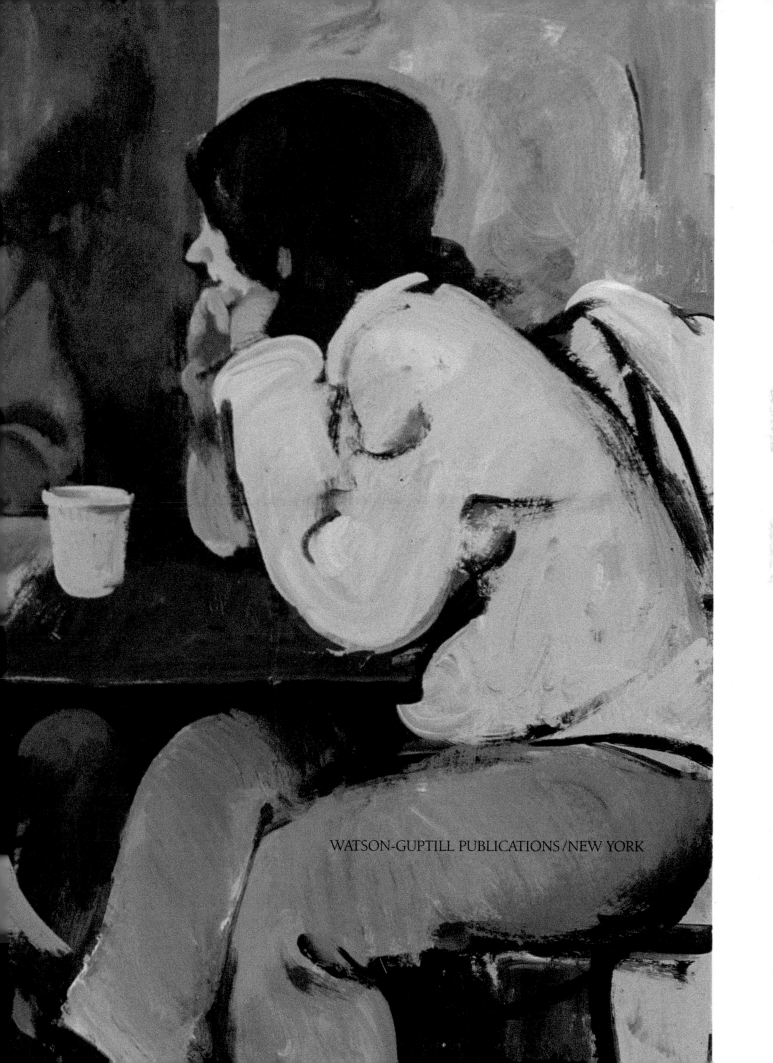

WATSON-GUPTILL PUBLICATIONS/NEW YORK

To my son, Lew, and to Zoia

Title page:
THREE FIGURES IN CAFETERIA
acrylic on illustration board,
30" × 40" (76.2 cm × 101.6 cm),
private collection

First published 1988 in the United States by Watson-Guptill
Publications, a division of Billboard Publications, Inc., 1515 Broadway,
New York, N.Y. 10036.

Library of Congress Cataloging-in-Publication Data

Hollerbach, Serge, 1923–
 Composing in acrylics.

 Includes index.
 1. Polymer painting—Technique. I. Title.
ND1535.H65 1988 751.42′6 88-17155
ISBN 0-8230-0869-X

Distributed in the United Kingdom by Phaidon Press Ltd., Littlegate
House, St. Ebbe's St., Oxford

Manufactured in Japan

First Printing, 1988

1 2 3 4 5 6 7 8 9 / 93 92 91 90 89 88

ACKNOWLEDGMENTS This book couldn't have been written if I had not for many years been an active member of the American Watercolor Society and made the acquaintance of its longtime president, Mario Cooper. He encouraged me to demonstrate how to paint in acrylic colors at many of the Society's annual exhibitions, and for these opportunities especially I want to thank him, for it was at one such demonstration that Bonnie Silverstein, then a senior editor at Watson-Guptill Publications, saw my work and subsequently suggested that I write a book on composing in acrylics. ❧ I want to express my gratitude to everyone who made this book possible, including Bonnie, who did the preliminary work on the manuscript; Marian Appellof, who expertly edited it; Bob Fillie, who designed the book; Tony Mysak, who did much of the photography; and Carol Kovac, who helped me with the typing.

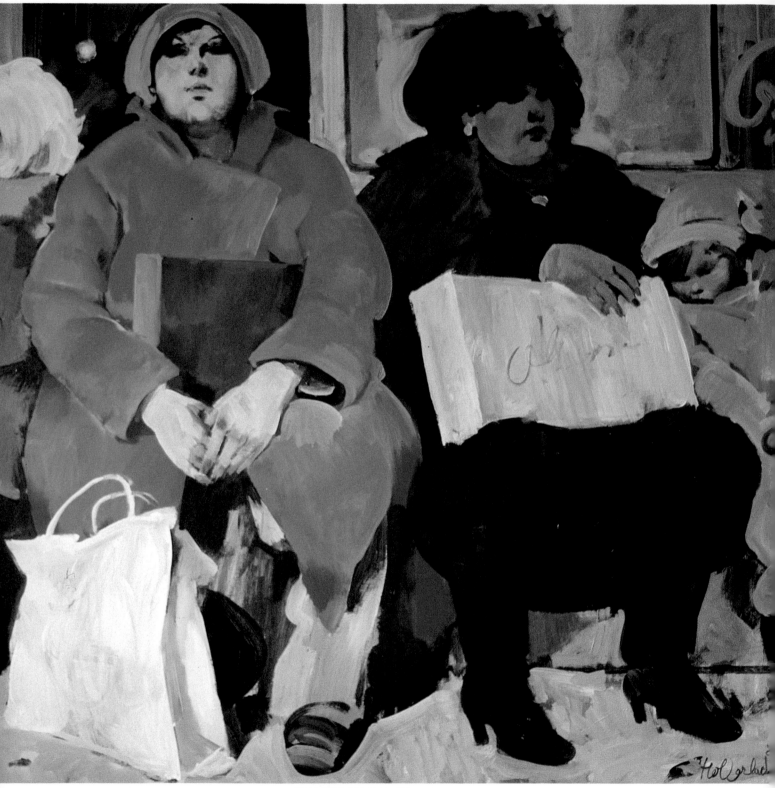

TWO WOMEN AND CHILD IN SUBWAY
acrylic on illustration board,
40″ × 40″ (101.6 cm × 101.6 cm),
courtesy Newman & Saunders Galleries

CONTENTS

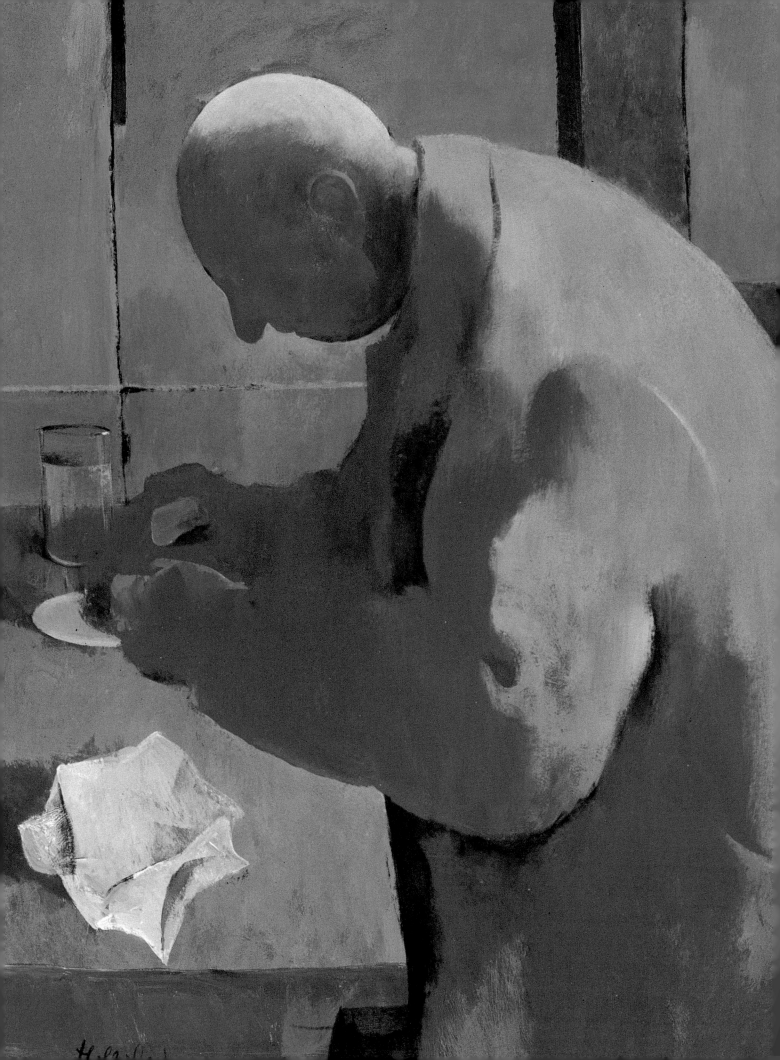

INTRODUCTION

In this book I would like to share my experience in working with acrylic paints. They are, in my opinion, an exciting and unique medium that has not yet been fully explored. Acrylics are especially well suited for composing paintings because they permit the kind of freedom an artist needs to work spontaneously—to change, adjust, eliminate, or add shapes and images at will in the shortest possible time and as often as needed, all without having to wait for the pigments to dry, without the prolonged buildups and sometimes complicated "kitchen secrets" that are common in oil painting. In other words, acrylics are a fast medium, direct and simple. And if handled well, they are capable of giving you the depth and richness of oils and the velvety flatness of gouache. Acrylics are not messy; they don't smell, they're water soluble and waterproof, and they work well on paper, cardboard, or canvas. ❧ Acrylics do, however, have one tricky trait, which is actually their great virtue: They dry very quickly. This takes some getting used to. Artists who are more comfortable with slow-drying oils may be deterred by this, but let me reassure you that acrylics can be "tamed" to behave according to your purpose. And once this happens, like noble animals, they become true and trusted friends that will never fail you, never pull a dirty trick on you. ❧ In the following chapters I will introduce you to acrylic paints and present some basic acrylic techniques, then will discuss the essentials of good composition. With that groundwork laid, I will go on to show you how best to exploit this medium's possibilities in different compositional genres—landscape, still life, portraiture, and figure painting, from memory and from life. ❧ My enthusiasm for acrylics is great and I hope to pass it along to you. As Georges Braque once observed, all painting is an adventure, a voyage into the unknown. With acrylics, the risks are minimal and the rewards surprising.

BREAKFAST
acrylic on illustration board, 40″ × 30″ (101.6 cm × 76.2 cm),
courtesy Newman & Saunders Galleries

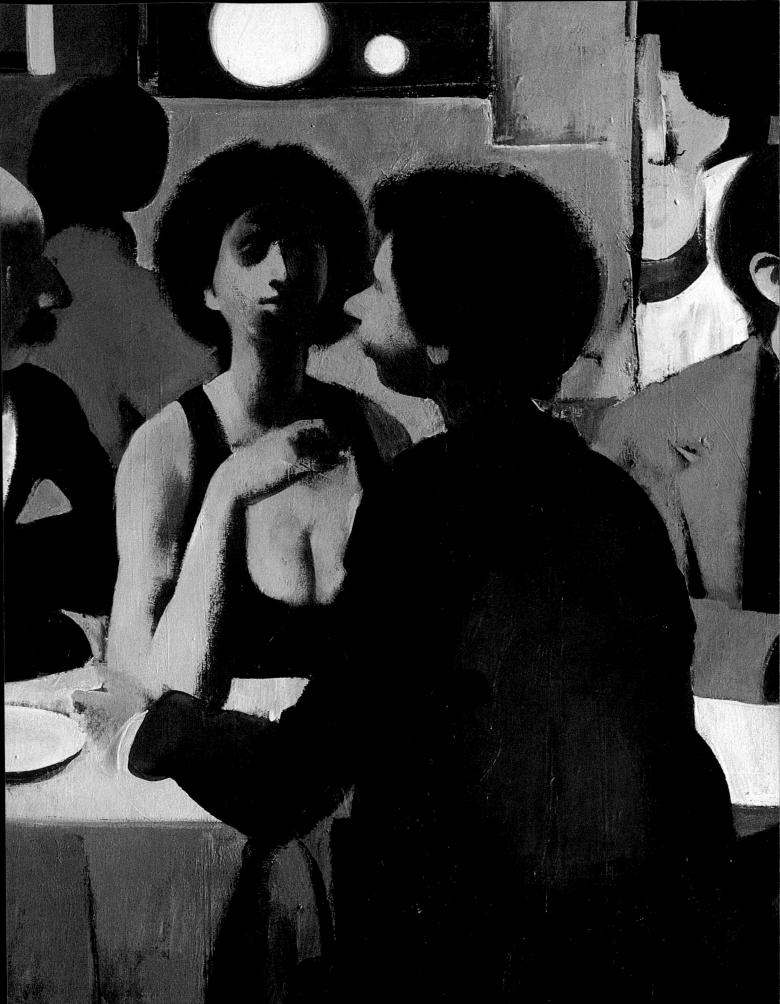

UNDERSTANDING ACRYLICS

I first tried acrylics some fifteen years ago and was quickly enthralled. The creamy smooth texture the paint had as it came out of the tube, the way it grabbed a surface, and the intensity of its color appealed to me and suggested great potential. Thus intrigued, I continued to work in this medium and have discovered just how versatile it is. ❧ Acrylics lend themselves remarkably well to a full range of painting techniques, from the thinnest, watercolorlike washes and glazes to opaque brushwork, including textured, impasto, and drybrush effects. Although acrylics work well as watercolors, when used as such they are so similar to regular watercolors that I won't discuss this way of handling them in the book. For me at least, the "true" acrylic is opaque acrylic. Applying the paint more heavily as you would when working in gouache, casein, or oil seems, in my opinion, to be the right way to use this medium and to offer the greatest range of possibilities. ❧ With acrylics, as you add more paint layers the quality of color changes for the better, and there is practically no danger of producing the muddy tones that result from earlier layers penetrating into fresher ones. On the contrary, tones and hues, while retaining their purity, acquire subtleties that are in no way inferior to those of watercolor or oil. ❧ Mastering acrylic techniques is not difficult. But like many other artists confronted with a new medium, you may be hesitant to begin. All my experience as an artist, from student days to the present, tells me that the fear of doing the wrong thing on canvas is the most repressive, inhibiting feeling an artist at any level can have. Yet we've all had it, or still have it from time to time. This lack of confidence comes from our honest and natural desire to do the right thing, to make a good drawing, to find the right color, to get the right expression. The fear of creating something ridiculous and ugly makes us timid. But if we want to create, we have to get rid of inhibitions. And the best way to do this in acrylics is to experience the paints physically, to move them around, smear and blend them. ❧ You don't need a lot of equipment to get started; the basic materials, as well as a few optional ones, are outlined here. And if you practice the fundamental techniques that follow, you'll have a command of the medium in no time.

RESTAURANT
acrylic on canvas, 40″ × 30″ (101.6 cm × 76.2 cm),
courtesy Newman & Saunders Galleries

MATERIALS AND TECHNIQUES

Pigments. Acrylic colors are available in tubes or jars, and there are many good domestic brands. Hyplar, Aqua-tec, and Liquitex are the most popular ones and seem to be of equal quality. I use all three and have no special preferences, although Aqua-tec makes a color I particularly love and use often— unbleached titanium. You should be aware that because paint formulas vary slightly from manufacturer to manufacturer, hues that go by identical names may differ. Although some artists advise not to mix different brands, I have never followed this rule and never noticed any ill effects. However, it may be safer to stick to a single brand when you run out of a particular color and need to replace it. 🐦 Here is a list of the colors I keep on hand:

	Titanium white
	Unbleached titanium (Aqua-tec)
	Mars black
Yellows:	Cadmium yellow light
	Cadmium yellow medium
	Mars yellow (Aqua-tec)
	Yellow ochre
Oranges:	Cadmium orange
Reds:	Alizarin crimson
	Cadmium red light
	Bright red (Aqua-tec)
	Cadmium red deep
Browns:	Raw sienna
	Raw umber
	Burnt umber
Greens:	Chromium oxide green
	Hooker's green
	Phthalo green
Blues:	Cerulean blue
	Cobalt blue
	Ultramarine blue
	Phthalo blue
Violets:	Dioxazine purple

Needless to say, I do not squeeze all of these on my palette, just the colors I am going to use for a particular painting. When preparing your palette, it's important to have both warm and cool varieties of basic colors, pairing off, for example, cadmium red (warm) with alizarin crimson (cool); Hooker's green (warm) with phthalo green (cool); and dioxazine purple (very warm) with phthalo blue (cool).

🐦 Occasionally I hear some talk that acrylics are still too new a medium to have withstood the test of time, and that they may not last as long as oils or tempera. I simply disregard such suspicions. Certainly the manufacturers of acrylic colors perform whatever tests are necessary to ensure the maximum durability of their products. As even a nonartist can see, acrylics are hard and rubbery when dry; they will not crack or darken as oils do, will not fade in the sun the way watercolors do, and will not smudge the way pastels do. Properly varnished with a matte or glossy acrylic medium, an acrylic painting looks and feels like an oil painting and is waterproof, whether its support is cardboard or canvas. In my opinion acrylics are, next to egg tempera, the toughest, strongest paints on the market today. And they continue to gain in popularity as time goes on.

Acrylic mediums. Mediums are various compounds that can be added to acrylic paints to enhance the way they flow from the

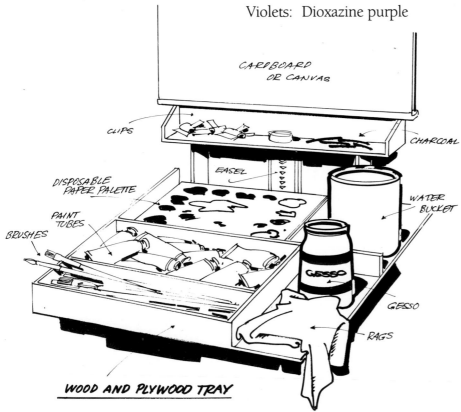

CARDBOARD OR CANVAS

CLIPS

CHARCOAL

EASEL

DISPOSABLE PAPER PALETTE

WATER BUCKET

PAINT TUBES

BRUSHES

GESSO

GESSO

RAGS

WOOD AND PLYWOOD TRAY

brush, to thin pigments and make them more transparent, or to impart matte, glossy, or impasto effects to the painted surface. They perform the same function that such substances as turpentine and linseed oil do in oil painting. ❧ Under this heading I also include acrylic gesso, a nonoily white paint that is used to prime canvas, board, or wood surfaces for oils, acrylic, and even watercolor painting. However, I use it when I need white in a painting. Instead of squeezing titanium white on my palette, I simply dip my brush into gesso. Because it is thinner than white paint, gesso works like a medium, making colors more fluid and easier to move, but at the same time gives them sufficient covering power. Only when I need a very solid opaque covering do I use titanium white. One other advantage gesso offers, especially if you do a lot of underdrawing, is that it can be applied over an already painted surface in such a way that allows the images underneath to faintly come through, thereby preserving the drawing while you experiment with new colors. ❧ But doesn't dipping a dirty brush into gesso make the whole jar dirty? Strangely enough, this doesn't happen. Liquid gesso just closes over the little dirty mark made by the brush the way water envelops a stone thrown into it. Only when you have used more than three quarters of a jar does gesso become somewhat dirty. By that time, however, it probably has formed a crust on top and is no longer in good condition. You can thin leftover gesso with water

and use it to prime cardboards. ❧ As for gels, retarders, modeling paste, and various matte and gloss mediums, I have tried them all and stopped using them, but only because I found that I would become so engrossed in the process of painting and composing that I'd forget I had them. Not using mediums didn't seem to make any difference in my work, since I like to paint fast. However, what doesn't suit me may work very well for others, so I encourage you to experiment with whatever is available. ❧ A few words on how some of these materials work:

Gel is a whitish paste, available in jars or tubes, that makes acrylic colors more transparent without thinning them. It extends the pigments and helps move them with ease. ❧ *Retarder*, also available in jars or tubes, looks like a transparent ointment or Vaseline and makes acrylic colors dry more slowly. You can put small amounts of gel and/or retarder on your palette and take a little on the brush when mixing a color. ❧ *Modeling paste* is used to create textures. It has the consistency of soft putty or plaster and can be applied with a brush or palette knife. ❧ *Matte medium* makes acrylic paint less shiny. *Gloss medium*, on the other hand, increases the gloss and gives added depth to colors. Both are good for glazing and can be used as adhesives for collages. ❧ Gloss and matte mediums are also labeled as *varnish*, which means that you can apply one or the other as a final coat to a painting to make it

either shinier or flatter and to protect it from dirt. Read the instructions on labels carefully. Paintings should be thoroughly dry before you varnish them. Use a soft, clean brush, and when the medium begins to dry, stop brushing or cloudiness may result. (You should be aware that most water media exhibitions and competitions specify that to qualify, a painting should be executed on paper or a paperlike substance—illustration board or cardboard, but not canvasboard—and *not* be varnished, but shown under glass or Plexiglas. Otherwise it will be classified as an oil.) ❧ Remember, it's not mediums that will make you paint in acrylics with ease and confidence; think of them instead as frosting on the cake. I believe very strongly that a direct, no-tricks approach to painting is the best and shortest way to success.

Painting surfaces. Acrylic colors work well on gessoed cardboard, acrylic-primed canvas, illustration board, and on almost any kind of good paper with the exception of highly absorbent cold-press watercolor paper (unless you're going to use acrylics as transparent watercolor). My favorite surface is Bainbridge 80 cold-press, kid finish illustration board, single thick for smaller paintings, double thick for larger ones. Canvas made of cotton duck or linen and primed with acrylic is excellent, too. Painting on it resembles working in oils, as acrylic paint dries more slowly on this surface than on cardboard. The only problem is, of

course, storage; stretched canvases need more space than boards, which you can easily stack up. 🐦 You can also paint on any gesso-primed cardboard. For color sketches I often use the strong cardboard backings of good-quality sketch pads. Why let a good painting surface go to waste? 🐦 Some artists will paint on anything paint sticks to. Even if durability seems less important today than it did centuries ago, do not use cheap, thin paper or board, even if you get interesting effects. For example, I knew someone who used pebbled mat board to paint on because its surface resembled rough linen. However, mat board is often quite acidic and, like other materials that were never intended for use as painting surfaces, is not a safe, permanent support. 🐦 Because acrylics are water-based, you also have to be sure the surface you apply them to is not oily; otherwise the paint will not adhere. Have you ever seen what happens to walls and ceilings that were once covered with oil-based paint and were later repainted with latex (which is basically acrylic)? Sooner or later this second paint layer peels off.

Palettes. Never use a wooden palette with acrylics—the paint will stick to it! Many artists use glass palettes or various plastic ones with covers and go to great lengths to keep the leftover paints moist—sprinkling them with water, wrapping them up in cellophane, and so on. But to me a disposable paper palette seems ideal. You just peel off the used

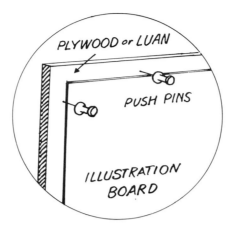

When painting on paper, illustration board, or gessoed cardboard, have a firm backing on your easel, such as a piece of plywood, and staple or pin your work to it with four to six long pushpins.

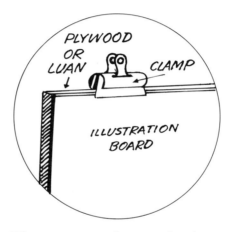

When painting on a larger surface, have a piece of plywood or luan—a thinner, finer plywood—cut to the same size and use clamps on the corners and sides to hold the two pieces together. Be careful not to paint over the clamps.

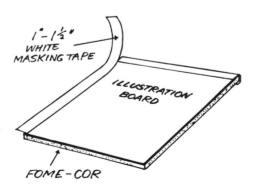

When you have to carry your work someplace, Fome-Cor board cut to the same size as your illustration board and secured to it with white masking tape on all four sides is especially handy.

sheet every time you need a clean palette—a fast tool for a fast medium. 🐦 A simple but important question: How much acrylic paint should you squeeze out and put on your palette? The answer is, don't be stingy! Considering how quickly it dries, a tiny amount of acrylic paint wouldn't do you much good. Thinning it with water will only make it like watercolor. Besides, spread thinly over a paper or glass palette, the paint will form "skins" that stick to your brush and are hard to remove from a painted surface. If you end up with unused color, you can save it; just cover your palette with thin plastic wrap, tucking in the edges. This will keep the colors reasonably fresh overnight, but no longer. A much more creative solution is to use remaining paint for doodling. Have small pieces of board, paper, or canvas handy and brush away with abandon with whatever colors you have left. This is an especially good way to loosen up.

Brushes. Have a good assortment of ten to twelve different kinds of brushes—flats, brights, rounds, and filberts—in sizes 6 to 20. Acrylics behave somewhat differently on the brush than oils or other types of paint do; experiment to find out which kind fits your technique and feels best to you. Brights are short, square brushes; flats are also square but longer. Both are good for creating sharp edges and modeling. Filberts are much longer and rounded at the end, and perform well when softer blending and free brushstrokes are required.

Completely round brushes (I have mostly large sizes) are the real workhorses of acrylic painting; they're good for rough applications of paint and for drybrush effects because you can twirl and rub them. A pointed sable brush, which you will need for finer details or for special brushstroke effects, is more sensitive than other types. You should have a fairly big one— size 20—and two or three very small ones. Don't buy the kind for watercolor, because they're too soft; select the ones made for oils, which are firmer and work better. 🎨 When I'm buying brushes I never look at the numbers and simply choose bigger or smaller according to what looks right; I don't need numbers to tell me that. What I am looking for is reasonably good quality, the right bristle length, and a good feel when I touch the bristle. Natural bristle or sable brushes are the best; brushes made of synthetic fibers that simulate these natural materials just aren't the same. I have found that they are either too coarse or too soft, and after some experimenting I stopped using them. 🎨 Working in acrylics makes cleaning brushes very simple: Wash them thoroughly with soap and water. You'll find, though, that acrylic paint wears out brushes much faster than oil or watercolor. Why? Probably because you rub them harder against the painting surface— acrylic paint is more gummy— and because no matter how careful you are, bits of acrylic paint accumulate at the base of every bristle, especially if you use, as I

Bright Flat Round Filbert

do, a lot of drybrushing. If neglected and gone completely dry, a brush with acrylic paint on it can rarely be saved. You can soak it in wood alcohol for a day or two, but it will never be the same. For thrifty painters who hate to throw anything away (I confess to being one of them), this ruined brush can still be of some use—for applying a very rough coat of paint, rubbing in crude shadows, or, finally, for stirring gesso in the jar.

Miscellaneous materials. I should mention some obvious "helpers" in painting. For instance, have plenty of cotton rags handy. Paper towels are not really good for acrylics; they are better for wiping off oil brushes. 🎨 A few single-edge razor blades are good to have around when lumps of acrylic paint build up on your board or canvas. Sometimes these lumps are all right, creating pleasant roughness and texture, but when they appear on

a painted face or on a bottle in your still life, they can be disturbing. When the paint is still wet you can simply take the lumps off with your fingernail; when dry, they have to be cut off. To do this without damaging the painted surface, hold the razor blade flat against the board or canvas and gently cut off the "wart." Then use some fine sandpaper to smooth the area. 🎨 Sometimes acrylic paint forms thin "skins" that stick to your brush and are carried to the painted surface. If you can't pick them up with your fingernails, try using a palette knife to scrape them off. Personally, I find the palette knife of little use in acrylics—the paint sticks to it. But go ahead and experiment with one. Just clean it as soon as you are finished. 🎨 Other than pencils and charcoal to do your drawing, there is nothing else you need to paint in acrylics.

Using a camera. Many artists use a camera to gather compositional information, and it can be a useful research tool. I have never used one in my own art because I find it restricts my vision. Photographs can, however, help you develop your visual memory. Take just the basic information from a photo— shapes, light and dark areas, and some details that are hard to remember—and sketch them roughly on your board or canvas. Then put the photo away and compose freely, relying on your memory. The end result should be a personal statement in the form of a painting, not a color photo rendered in acrylics.

MIXING AND BLENDING
The simple exercises presented here will help you get the feel of acrylic paints.

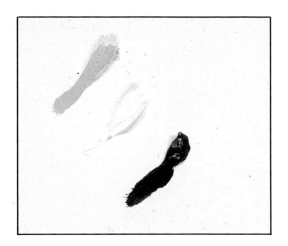

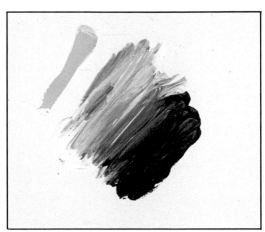

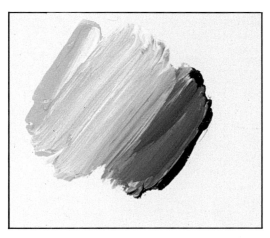

Exercise One. *Squeeze out small amounts—as much as the toothpaste you put on your toothbrush—of yellow, titanium white, and phthalo blue onto a piece of illustration board, placing white in the middle and the other colors about an inch away from it. Take a good-size bristle brush, flat or bright, and dip it in water, shaking off the excess. Brush blue paint into white. Wet another clean brush and bring yellow paint into white. Repeat the procedure several times, overlapping the colors until you have a fairly good blending. Try different colors. Vary the amount of paint on your brush, going slightly thinner or thicker. The paint should spread like very soft butter over warm toast.*

Exercise Two. *Dip a brush into gesso and immediately pick up some paint (alizarin crimson, for instance) from the palette. Brush it on the board or canvas, mixing gesso and pigment right on the painting surface, not on the palette.*

Exercise Three. *Blending is easier and finer when the surface is wet; to experiment with this, cover a piece of board with gesso or with some color, making sure you have a solid opaque layer of paint on it. While the surface is still moist, blend different colors into it, brushing vigorously.*

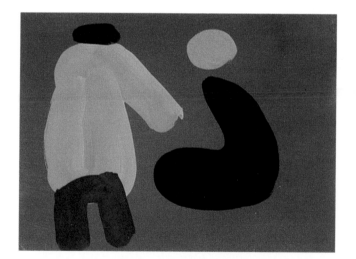

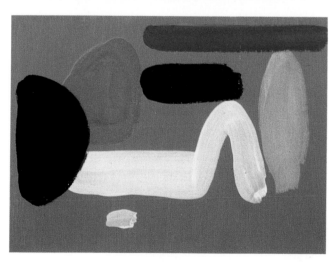

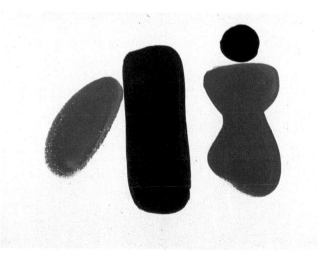

Exercise Four. *Try heavy brushstrokes of light color, using titanium white or gesso to make it opaque, over a dry dark background. Or try dark brushstrokes over a light background. Notice the different effects.*

COLOR DOODLING Use any occasion to become familiar with the qualities of acrylic colors. As I mentioned earlier, color doodling is the best and most creative way to do this; with the paints remaining on your palette you can make quick color sketches of things around the house, color notations, or simply cover bits of cardboard or paper with whatever comes to mind. You may be surprised to see color combinations you've never imagined, or discover shapes that suggest figures, objects, or components for a landscape; you never know when these may be of use. Such exercises are artistically and psychologically healthy because they allow you to relax and feel the paint qualities and possibilities more easily than when you are involved in results-oriented painting. You can go as abstract or as expressionistic as you feel; these instincts exist to some degree even in the most realistic painter. 🙠 If some of your doodles seem interesting enough, add a few details here and there, and unexpectedly, you've got a small painting. It's like making a gourmet dish out of leftovers. Here are a few of my own doodles, and some made into small paintings.

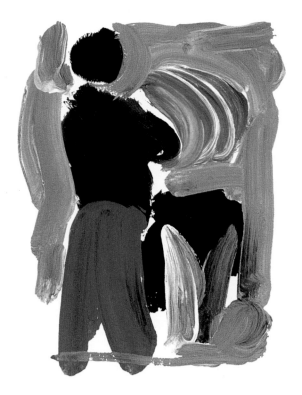

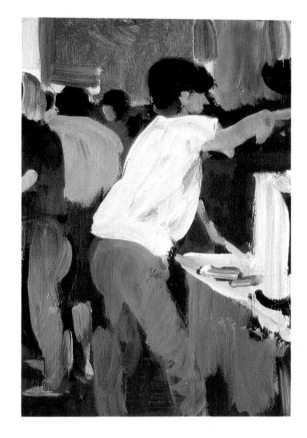

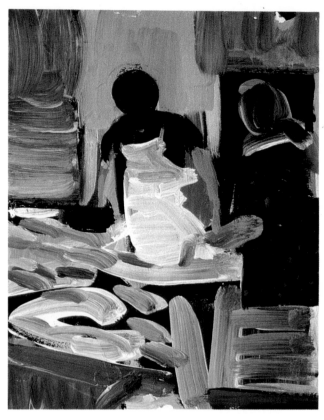

DRYBRUSH As you become familiar with moving and blending acrylic paints, you'll want to explore some other techniques. The best is, in my opinion, the drybrush. ❧ Anyone who has painted in transparent watercolor knows drybrush to mean dragging a loaded brush with a minimum of water over the paper's surface to leave white areas exposed beneath the paint. In acrylics the technique is somewhat different and works more the way crayons and pastels do. ❧ To do a drybrush rendering in acrylics, you don't need water at all. Take a good-size round bristle brush and, without wetting it, scoop up some freshly squeezed paint. Rub it on a board or canvas with a circular motion until you run out of pigment. Immediately pick up another brush, take a different color, and work toward the first color area, eventually overlapping it. Pick up your first brush— now almost dry, but still a little tacky—and overlap the second shading. You'll see a somewhat grainy shading, very much like in pastel, as the example at the top of the page shows. Don't forget to dip both brushes in water as soon as you have finished your experiment. ❧ This kind of shading is perfect for rendering round forms like jars and bottles or arms and legs. But it is also good for covering larger areas representing shadows and for adding lighter shapes on top. As these small paintings illustrate, things like fabric folds, shadows, and subtle light and dark areas on faces are easily rendered in this fashion.

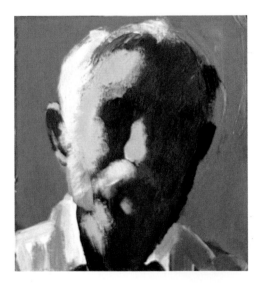

Can you drybrush with a pointed sable brush? Yes, of course; the technique lends itself well to depicting the swift movement of hair and elegant curves and curls. The brush should be semidry, the surface completely dry. *Head of an Old Man* was done this way.

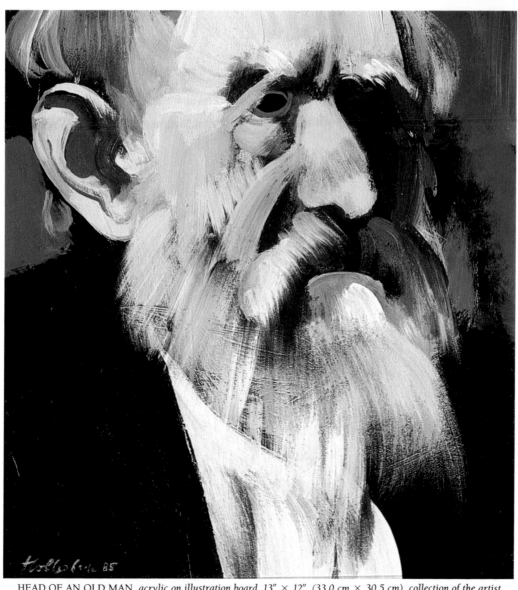

HEAD OF AN OLD MAN, *acrylic on illustration board, 13″ × 12″ (33.0 cm × 30.5 cm), collection of the artist*

DRYBRUSH

Another interesting experiment is to use the drybrush technique on a painted surface that isn't quite dry yet. You'll produce a fine, subtle shading very similar to the wet-in-wet blending method mentioned earlier. 🐦 It's fascinating to create different atmospheric conditions at will, and free-shape drybrushing is ideal for this. Practice painting light clouds on a darker sky—blue, gray, or stormy—to see what effects you get. You can also depict smoke, dust, or steam with this technique. 🐦 Every artist eventually finds his or her own way in working with acrylic drybrush. Some prefer a little more moisture, some vary the paper or canvas textures; there is no limit to your experimentation. The main thing is, you should be completely comfortable and sure with the kind of brush you are using and with the consistency of the paint.

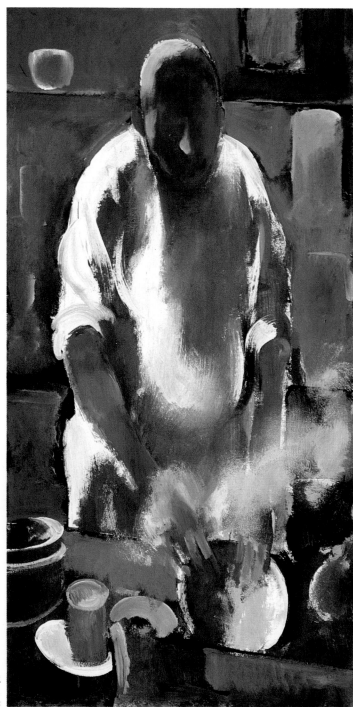

DISHWASHER
acrylic on illustration board, 40″ × 20″ (101.6 cm × 50.8 cm),
courtesy Newman & Saunders Galleries

GLAZING Another interesting technique in acrylic painting is glazing, which differs from what we usually understand this term to mean in oil painting. To me, glazing means more than washing thin layers of paint over a dry painted surface to change its tonality, to strengthen, brighten, or subdue the underlying color. That, of course, can be done, but I don't practice it. In my experience, the following approach can be of value. ❧ Let's say you want to paint a transparent bottle. Mix a very liquid greenish-white paint and, using a pointed sable brush, paint the shape of a bottle on a dark background. While the paint is still wet, take a cotton wad or a small rag and wipe off the middle. Repeat this a few times until you are satisfied with the results. I use this technique to paint balloons, shiny round objects, transparent fabrics, window-panes, and the like. You can also wipe wet paint completely off a dry surface and clean it with a wet rag. ❧ Quite often if I'm not fully convinced that a correction I plan to do on a hand or face is really needed, I paint it on quickly in fairly liquid pigment. If it looks wrong, I wipe it off. If it looks right, I let it dry and repeat it in thicker paint. ❧ Practice both drybrushing and glazing often. Make them part of your color doodling, and you'll get unexpected results.

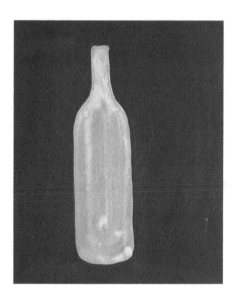
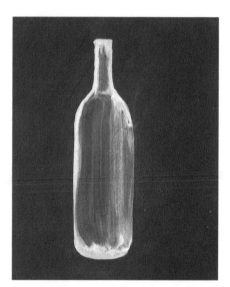
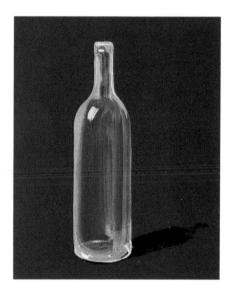

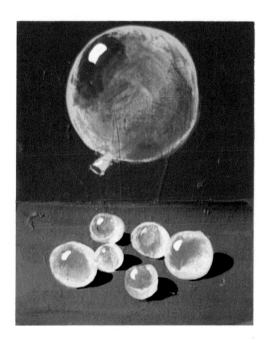

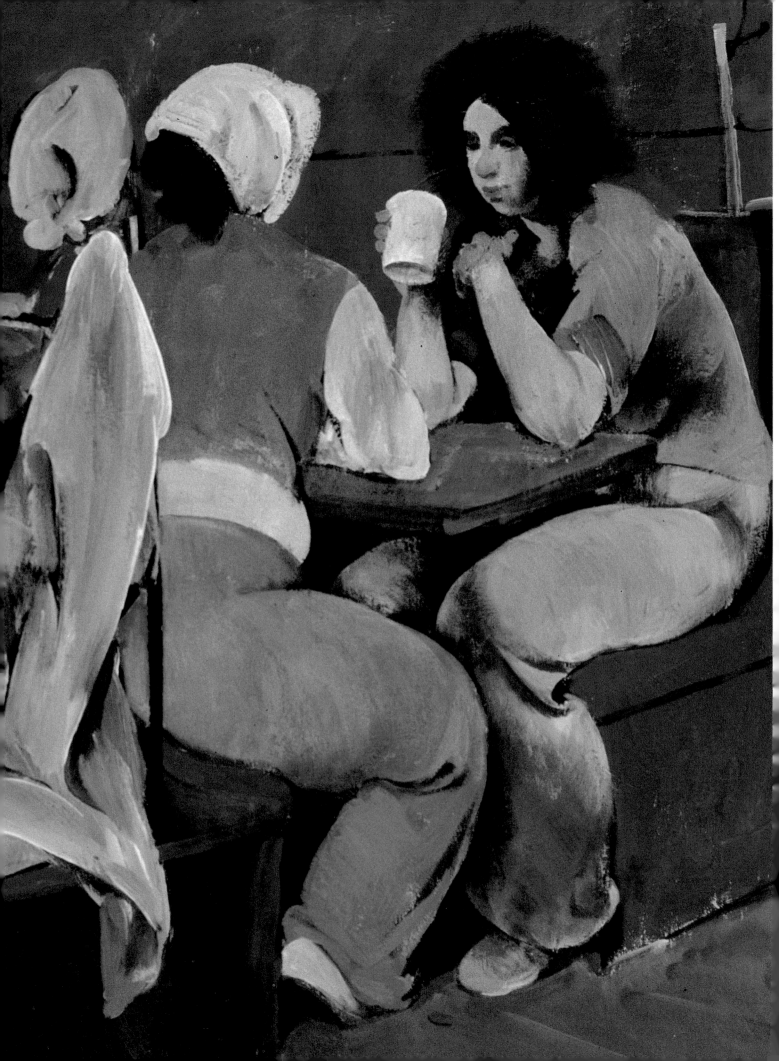

THE PRINCIPLES OF GOOD COMPOSITION

Now that you have familiarized yourself with the physical properties of acrylic paints, it's time to grasp a few compositional lessons to help you make pictures that will work. I'm going to assume that you have some basic knowledge of the human figure, light, shadow, perspective, and so on. It doesn't matter at this point to what degree. ❧ Very often the success or failure of a painting depends not on the level of your rendering skills, important as they may be, not on how well you depict reality, but on construction, on how a painting works in terms of balances, tensions, and harmonies. In other words, on composition. ❧ Let us always remember that masters of the Middle Ages and early Renaissance didn't know as much about depicting reality as High Renaissance painters or the nineteenth-century realists did. Yet they created great works of art. Giotto's figures, for example, are certainly not as lifelike as those of Titian, Velásquez, or Rubens, but in their rhythmical beauty, noble expressiveness, and grandeur they are as sophisticated as anything done afterward. They were beautifully composed. ❧ Of course, Giotto was a great artist of his time, and it is unfair to compare lesser artists of other times, ours included, with his genius. Nevertheless, I do believe that composition is the key to successful painting. Even helpless rendering can be overlooked if the composition is strong, convincing, and expressive. Just consider in more recent times works by such a phenomenon as Henri (Le Douanier) Rousseau, or by Haitian and Yugoslav primitives, or, farther back, Colonial American folk artists. There are many examples of artworks in which compositional expressiveness compensates well for what is lacking in realistic rendering. ❧ I have thought a lot about composition but never read any aesthetic treatises or theories on the subject. Perhaps I should have. But inventing a steam engine completely on your own without knowing that it has already been invented is still a rewarding experience. I would like to offer my own homespun theories on composition as they have crystallized in my mind over many years. I follow them in every painting I do. ❧ What is a good composition? Are there any rules? Yes, there are, although they should actually be thought of as principles to experiment with. Art, after all, is not an exact science.

TWO GIRLS IN A BOOTH
acrylic on illustration board, 40" × 30" (101.6 cm × 76.2 cm),
courtesy Newman & Saunders Galleries

BALANCING WEIGHT

Good composition implies, first of all, a certain kind of harmony, a sense that all things in a painting are united. Harmony requires a balance between one element and the next. And balance, in turn, suggests *weight*.

❧ Think of how you would arrange furniture in your living room. You wouldn't put all the pieces—couch, table, bookshelves, chairs—in one corner, leaving the other ones empty; even a nonartistic person will instinctively distribute objects by weight and proportion. Artists do the same thing in setting up a composition. ❧ The simple schematic drawings shown here illustrate three of the most common ways weight can be balanced. And as the paintings themselves demonstrate, balance is achieved not only by the size and distribution of shapes in a picture, but also by contrasting dark and light colors. In your painting this means simply that a dark and thus heavy area should be offset by a sufficiently large area of lighter color, or a group of small dark shapes with a larger dark shape; or that darks should be distributed in such a way that light areas work as counterbalances. Taking things a step further, the intensity of a color has "weight," too; bright colors weigh more than pale, subdued ones. Artists use infinite combinations of strong and subtle colors to create harmonious balances. After some practice, instinct will guide you.

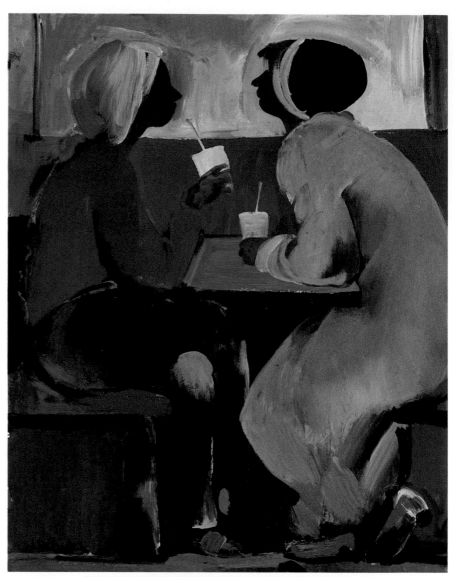

TWO GIRLS WITH SOFT DRINKS, *acrylic on illustration board, 40" × 30" (101.6 cm × 76.2 cm), collection of Thomas P. Whitney*

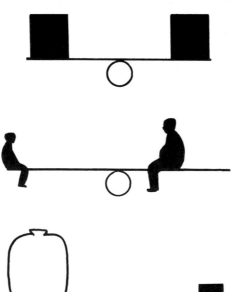

Equal Weights. *When objects of equal weight are placed on each end of a scale and at the same distance from its center, equilibrium results. This is the classic, one-to-one situation most people understand, and is the principle played out above.*

Unequal Weights. *For two people of unequal weight to balance on a seesaw, the heavier person must sit closer to the fulcrum, or center, and the lighter person must sit farther away from it—something we know from school days.*

Weight vs. Volume. *You can also balance weight in terms of volume; here, a large-size bag of some light material offsets a smaller but denser object of equal weight.*

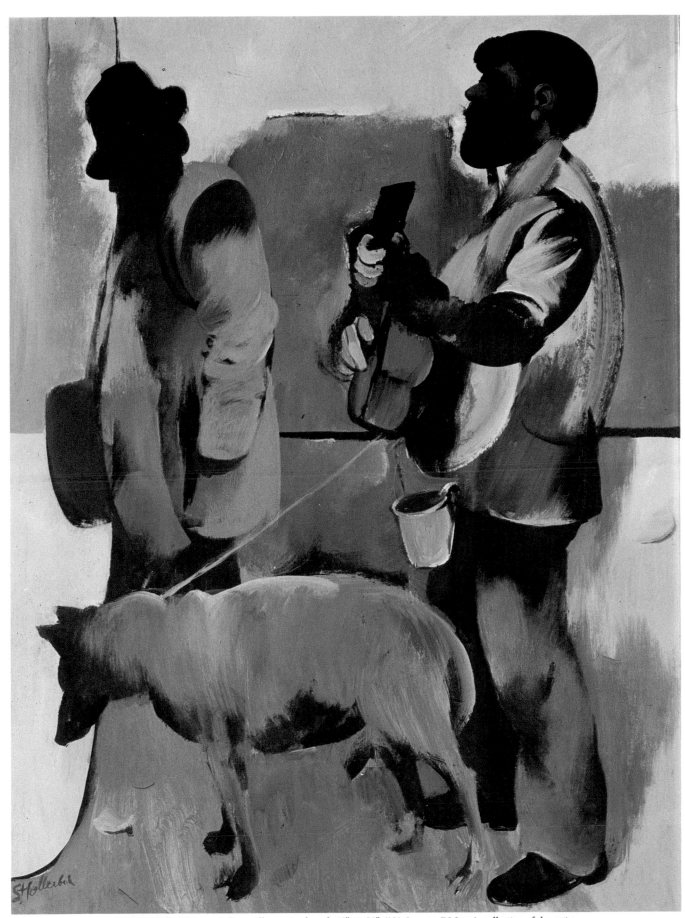

BLIND MUSICIAN, *acrylic on illustration board, 40″ × 30″ (101.6 cm × 76.2 cm), collection of the artist*

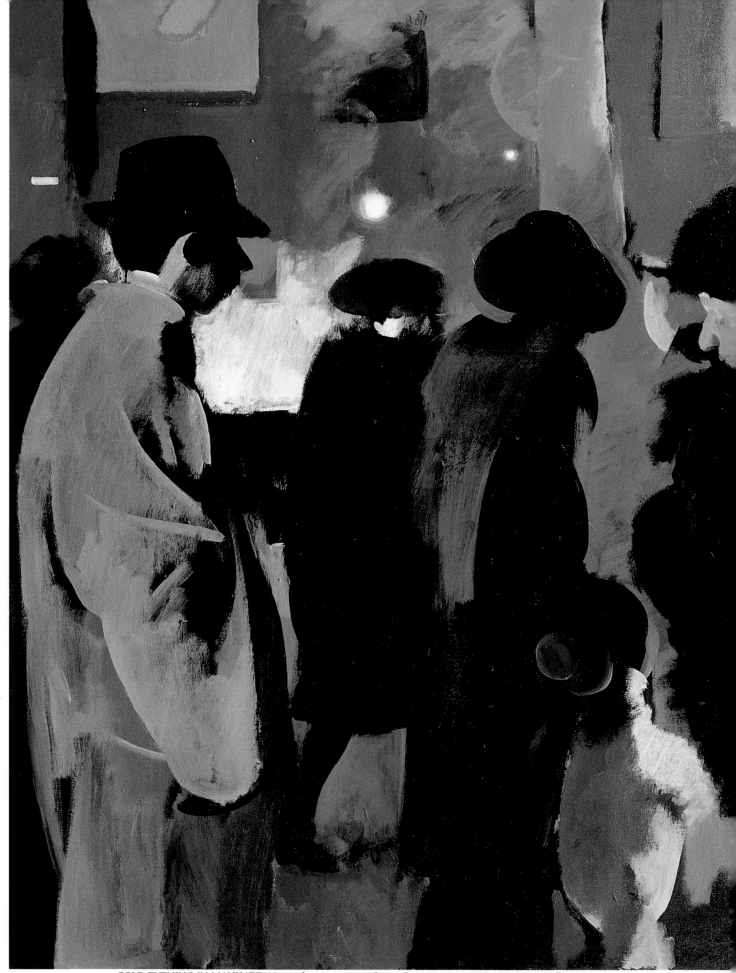

COLD EVENING IN MANHATTAN, *acrylic on canvas, 40″ × 30″ (101.6 cm × 76.2 cm), private collection*

BALANCING WEIGHT

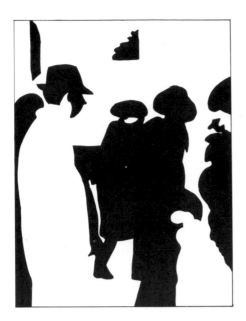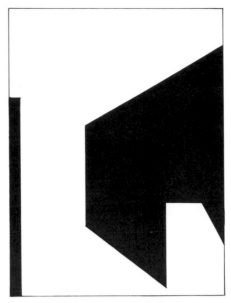

In the painting *Cold Evening in Manhattan*, I have balanced the lighter figure of the man on the left with darker figures on the right, as the first schematic drawing shows. Lighter areas are larger than the dark ones and surround them, keeping the balance, as the second schematic drawing shows. ❧ In *Oriental Fish Market*, small dark areas— heads, sleeve, shadows—are scattered around to maintain an equilibrium.

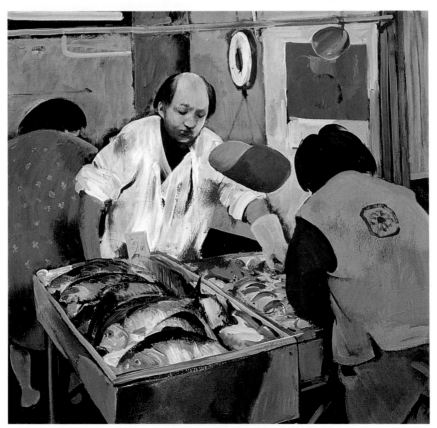

ORIENTAL FISH MARKET
*acrylic on illustration board, 40" × 40" (101.6 cm × 101.6 cm),
courtesy Newman & Saunders Galleries*

DIRECTIONAL ENERGIES Besides balanced weight, I always consider what I call "directional energies" in my compositions. Figures, trees, or shadows that lean diagonally always need something to counteract them; otherwise they will shoot out of the picture, making it unbalanced. The schematic drawings that accompany the paintings shown here distill three simple compositional situations. 🐦 In the painting below, an X scheme is clearly visible. The diagonal formed by the woman's arms and the stroller handles crosses the crack in the floor, and all the other details go the other way or are at different angles. Also, the baby and stroller on one side support the forward-leaning figure of the mother on the other side, exemplifying another scheme.

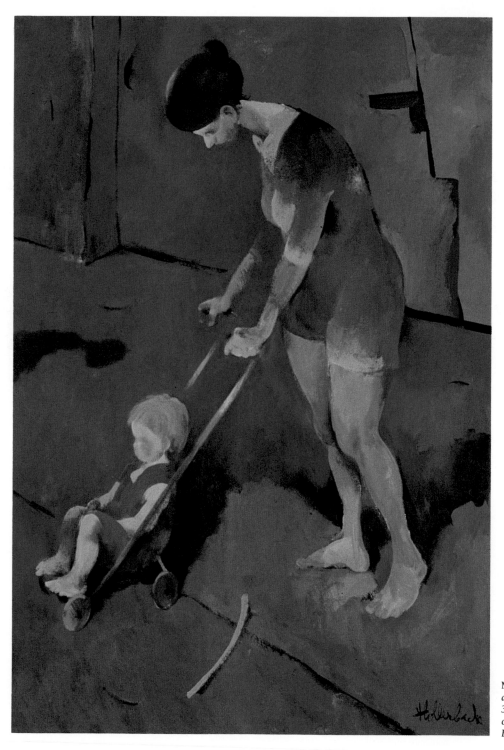

MOTHER AND CHILD, SUMMER
*acrylic on illustration board,
39" × 27" (99.1 cm × 68.6 cm),
collection of Citizens Fidelity
Bank and Trust Co., Louisville, Ky.*

This composition is based on a scheme of two curved lines.

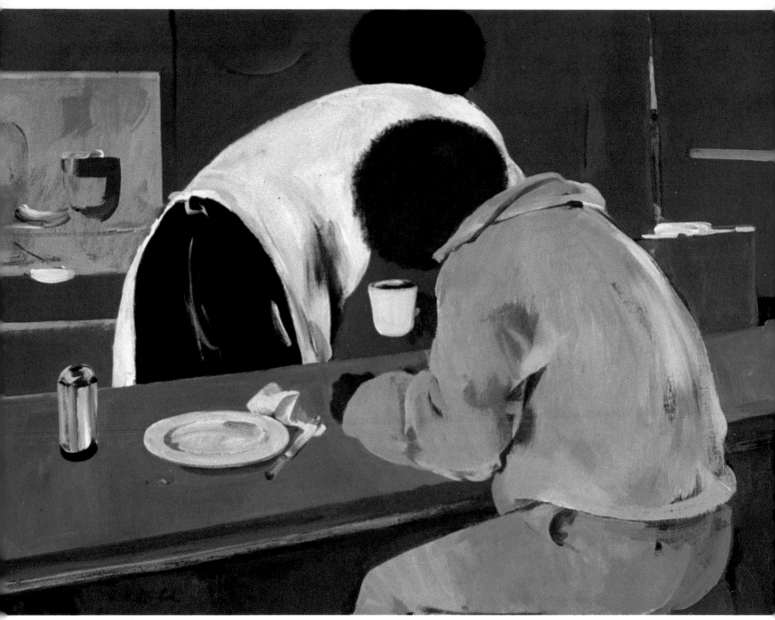

RED LUNCHEONETTE, *acrylic on illustration board, 30″ × 40″ (76.2 cm × 101.6 cm), collection of the artist*

DIRECTIONAL ENERGIES

Here is a more complex situation in which directional energies fan out, counteracting, pulling, and balancing one another.

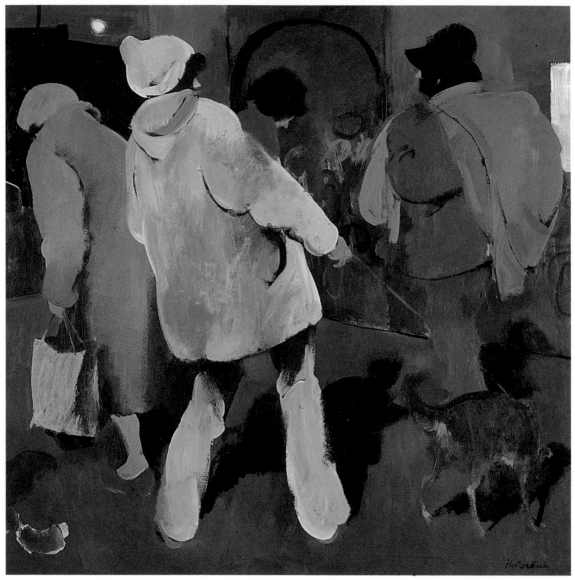

STREET SCENE WITH A DOG
acrylic on illustration board, 40″ × 40″
(101.6 cm × 101.6 cm), courtesy
Newman & Saunders Galleries

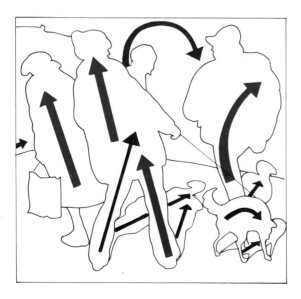

LITTLE ITALY
*acrylic on canvas, 44" × 48" (111.8 cm × 121.9 cm),
courtesy Newman & Saunders Galleries*

OVERALL PATTERN Another compositional possibility is to create an overall pattern, a carpet effect in which everything is spread out evenly. This format is not as dramatic as the others and I do not use it often. In *Ocean Beach II* the figures are scattered around the picture. But notice in both the diagrams and the painting that all the shapes and figures are still placed at angles that keep directional energies and weight balanced. ❧ As I discuss how to develop different kinds of paintings, I'll often come back to these principles of composition, to the almost semiabstract schemes that form the skeletons of my own works.

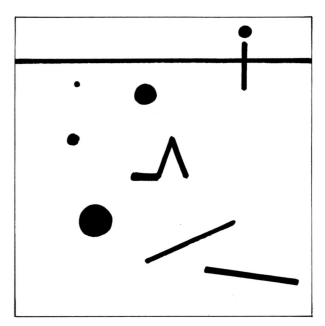

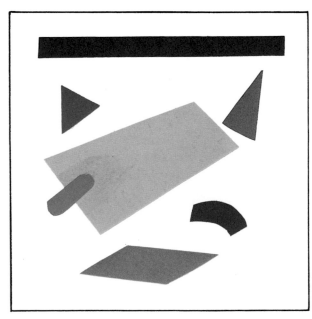

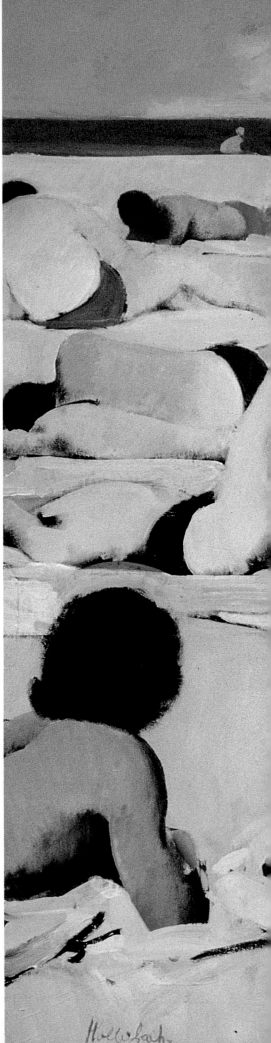

OCEAN BEACH II
*center panel of triptych
acrylic on illustration board,
40″ × 40″ (101.6 cm × 101.6 cm),
collection of Dr. and Mrs. Charles Minehart*

34

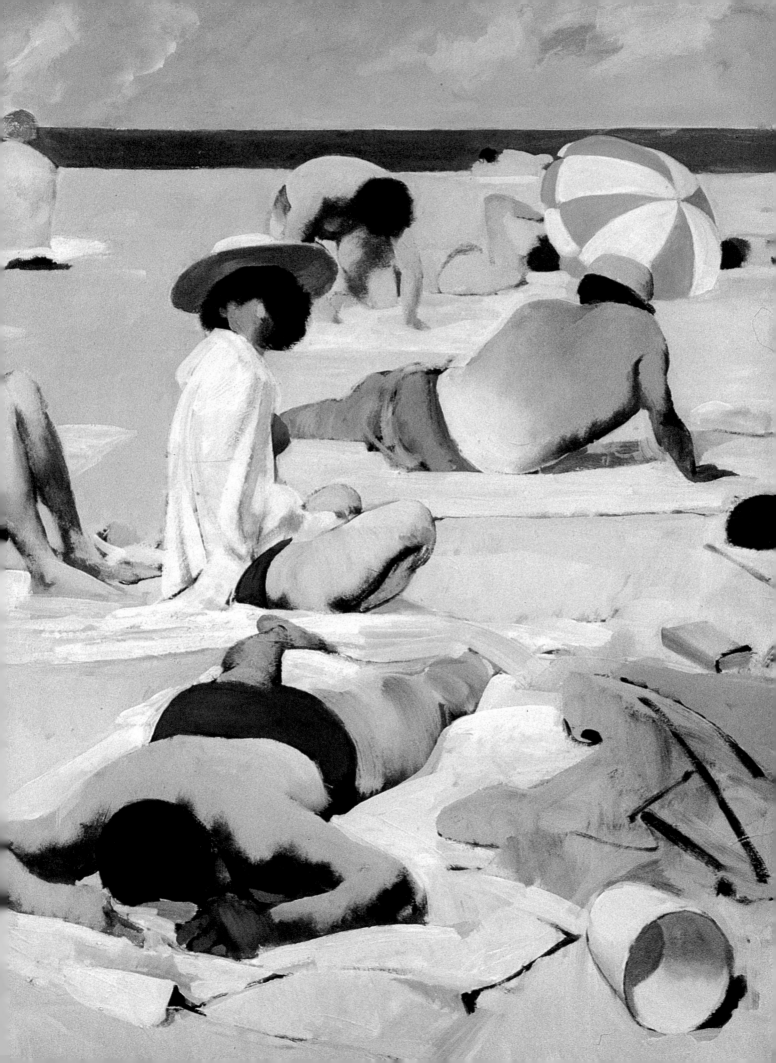

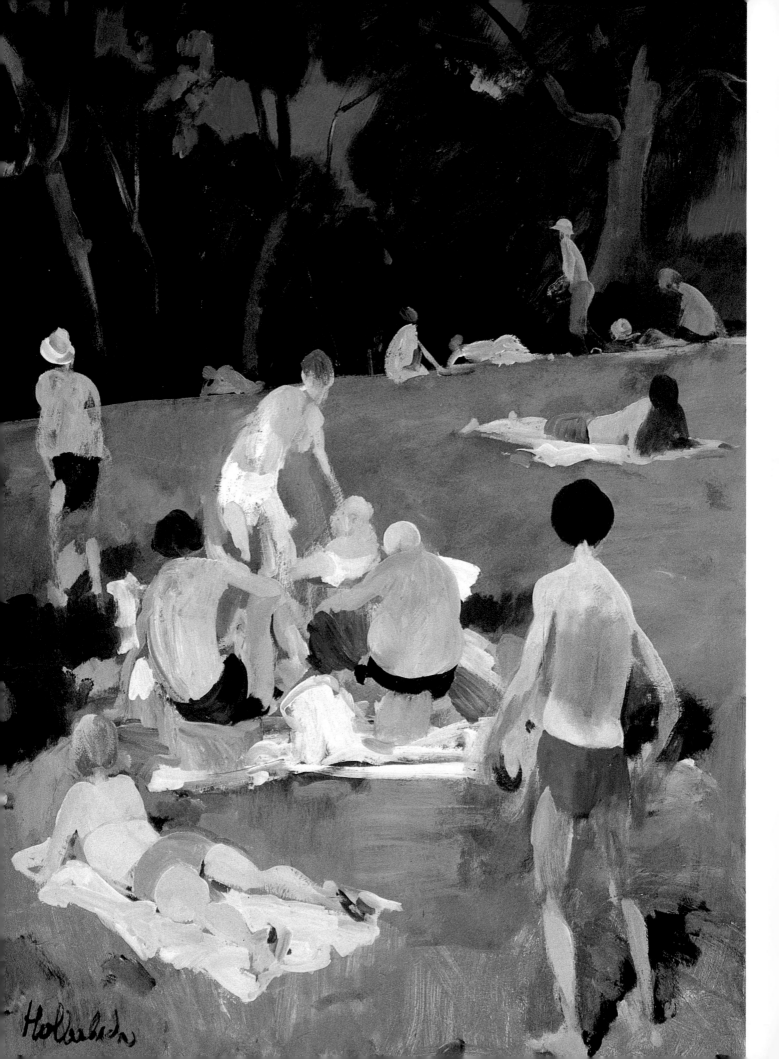

PAINTING LANDSCAPES

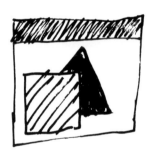

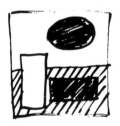

Landscape painting is one of the most important and helpful activities for a painter no matter what your specialty, because it teaches you to see simple color and value relationships and to understand light. Whether you do a landscape on the spot, from memory, or from a photograph, you have to train your eye to see certain basic things. Whenever I walk or drive in the city or countryside, I make it a habit to "paint" with my eyes, to memorize the different relationships in a landscape. Then at home I put all this visual information down on paper or canvas in color. ❧ First of all, there are values: The sky may be very light, the ground darker, a forest in the background darker still. Notice these elements and remember them. Note too, however, that these values may change dramatically depending on the hour of day and weather conditions—the sky becomes darker than the ground; trees become sunlit and cast shadows. ❧ Remember the proportions of what you've seen—large light area, smaller middle area, narrow very dark area, and so on—as well as vertical, horizontal, and diagonal compositional elements. Abstract and reduce trees, houses, and the various other components you see to geometrical figures that approximate them. A scene is easier to remember if you can think of it as a simple combination of shapes—a square, a triangle, and a stripe, or two rectangles and an oval. ❧ Next, memorize the dominant colors—light gray sky, warm green ground, and dark green trees, for instance—and if possible, try to be aware of subtler hues too, such as purplish gray or yellowish brown. ❧ Finally, always try to capture the light in your mind, especially in the morning or in the evening, when it is most beautiful. ❧ I paint landscapes outdoors as well as indoors from memory; many artists combine both activities by making a small sketch on the spot and developing it into a painting in the studio. I myself have never mixed the two approaches, perhaps because I want to be true to what I see when I'm outdoors and completely free to do what I please when in the studio. But every artist responds to landscape differently, and method is a very personal matter.

PICNIC IN THE PARK
acrylic on illustration board, 40″ × 30″ (101.6 cm × 76.2 cm),
collection of Mr. and Mrs. Kendrick Wells

COMPOSING FROM MEMORY I live near a park and observe people sunbathing, picnicking, or just relaxing in the shade of the trees. When I want to make a painting of a landscape, I begin with simple sketches from memory of scenes witnessed at this spot close to home. As I think about how I want to put the composition together, I consider the main elements, which consist of the sky, the trees, and the green grass littered with pink, yellow, and white silhouettes of people. (One day, believe it or not, looking at my lunch of cooked shrimp on a green salad leaf, I thought how much it resembled a park scene. Art haunts you even while you are eating!) ✒ Just as a reminder to myself of what I have seen so often, I did this little park scene.

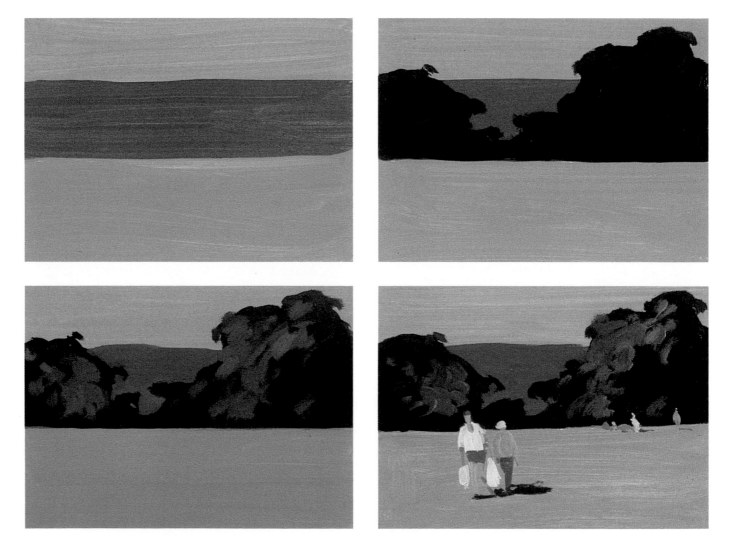

The compositional structure in this case, as in most landscapes, was very simple: three bands of color, one for the sky, another for the middle ground, a third for the foreground. I blocked these in one, two, three, keeping values and colors different. Next came the dark silhouettes of the trees, with a lighter green to suggest sun shining on their leaves; then I sketched in a few figures. All this took less than an hour.

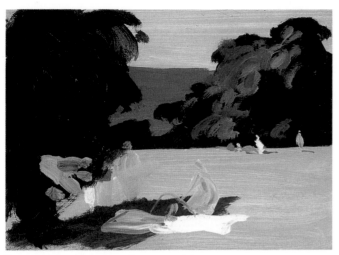

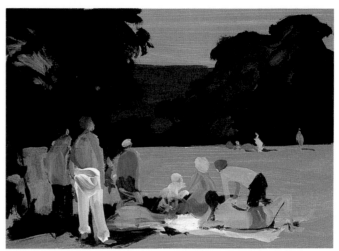

But soon I realized that the composition was too empty, too calm for my taste. Radical changes could help. By adding another tree on the left and suggesting larger figures and a white blanket, I made the picture potentially more interesting.

It then called for more figures. Designing a group of people, I followed the compositional principles I discussed earlier and put down some shapes, adding others to complement them the way I do in my color doodling. The result was a picnic scene.

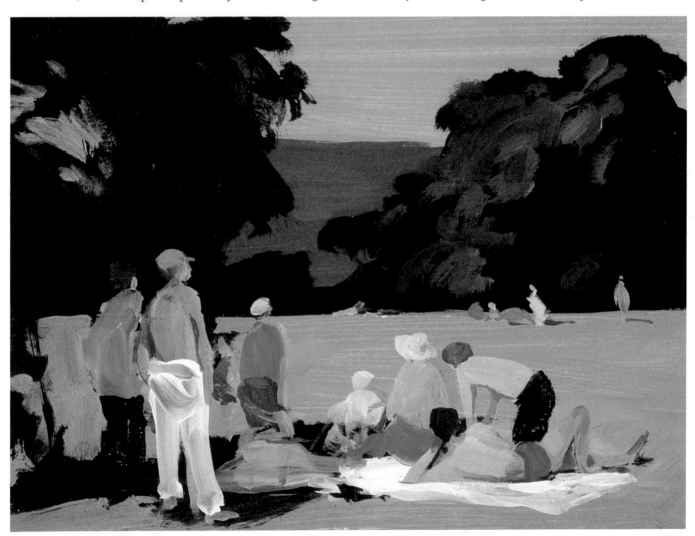

I let some time pass, analyzed the group, and made a few small changes: a cap on the figure in white slacks, a straw hat on the sitting figure in the center, shadows and accents here and there. I deliberately left broad brushstrokes intact, as this is a small sketch and a certain roughness creates an easy and casual feeling. People in the park are the subject of many other paintings I have done in the last few years; I call them my "Shrimp on a bed of lettuce" series.

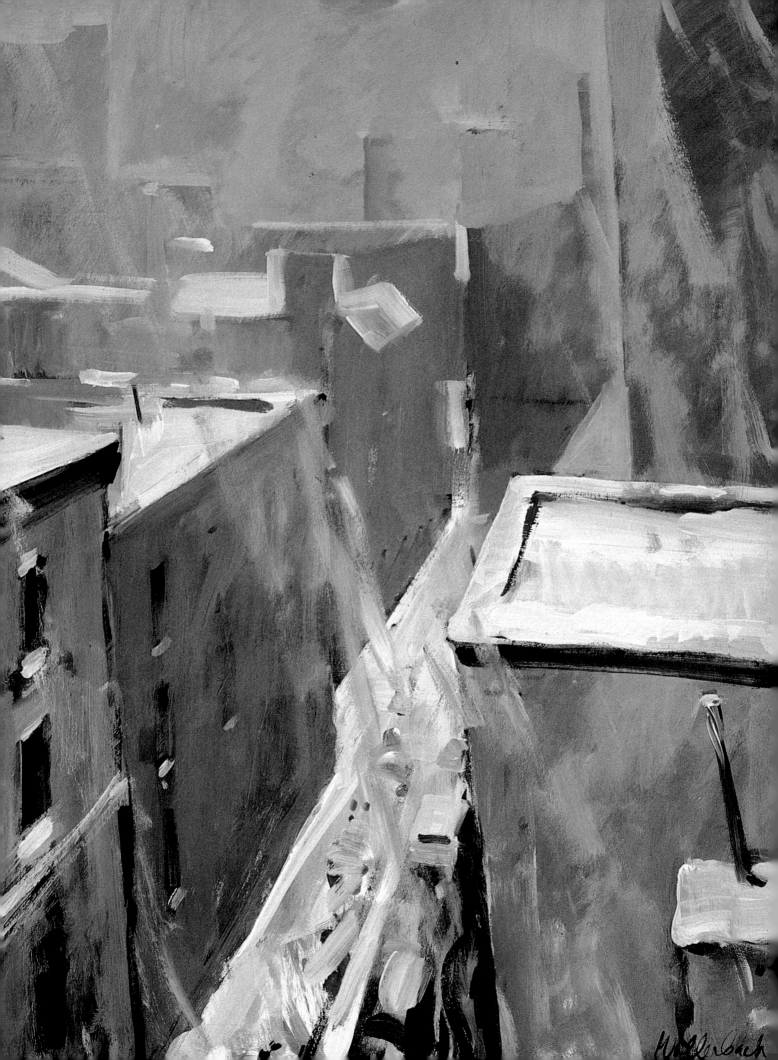

PAINTING WINTER SCENES

Artists are usually seasonal people; they paint summer scenes in summer, winter scenes in winter. I do so, in any case. Winter scenes are a recurring theme in my work. I do them from memory (I don't like to paint in the cold!); *City in Winter,* opposite, is perhaps the only exception, as it was partially done from life. It is a view from my studio window in Manhattan. But as I composed the painting, I changed some buildings and regrouped others, because I was trying to express the feeling of a snowstorm rather than faithfully reproduce a complex architectural ensemble. Usually I don't take such liberties, but I'm not very good at architectural detail, and this was a legitimate way out. 🐦 In wintertime the landscape is easy to memorize because the black and white contrasts are so strong. While driving through rural New Jersey, I observed a particular snowy vista on many occasions. Here, step by step, is how I painted it.

Step One. *First I divided the board into two areas, gray sky and black ground. Then I blocked in the colors, using gesso with black, phthalo blue, alizarin crimson, and a touch of yellow ochre for the sky and black, burnt umber, burnt sienna, and phthalo blue for the ground.*

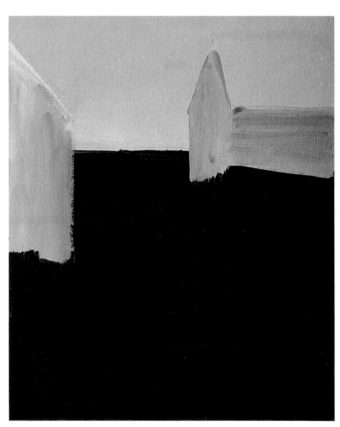

Step Two. *Next I put in the shapes of the houses, remembering that they shouldn't be too light. I used gesso, yellow ochre, burnt sienna, and touches of blue and black.*

CITY IN WINTER
acrylic on illustration board,
40″ × 30″ (101.6 cm × 76.2 cm),
collection of Mrs. Elizabeth Hooper

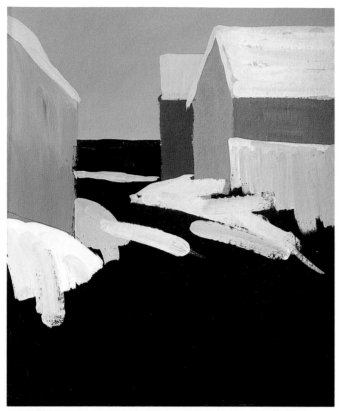

Step Three. *Here I added snow in bold brushstrokes, keeping in mind that the whitest snow should be in the foreground.*

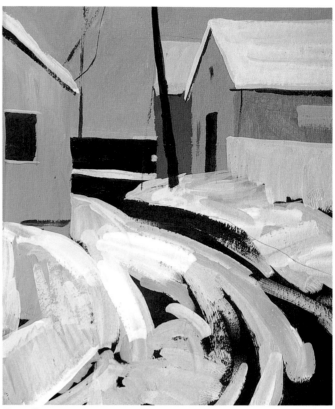

Step Four. *More snow, dark trees, windows. I used gesso, not titanium white, for the snow.*

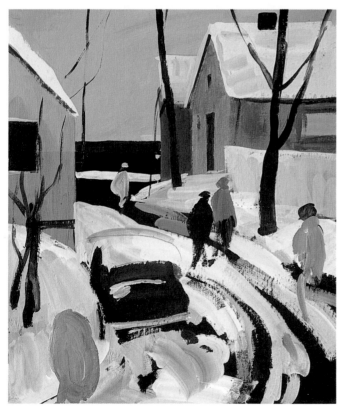

Step Five. *I attempted to liven up the scene with the shape of a dark, snow-covered car and some figures. To bring the foreground forward, I made the figure closest to us wear red.*

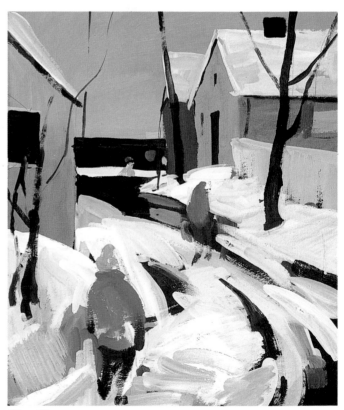

Step Six. *After deciding that the composition was too busy, I started to eliminate some figures; less is more. Added blue to figure in front, as red seemed too strong and too obvious. Got rid of the car and added a traffic sign in the background.*

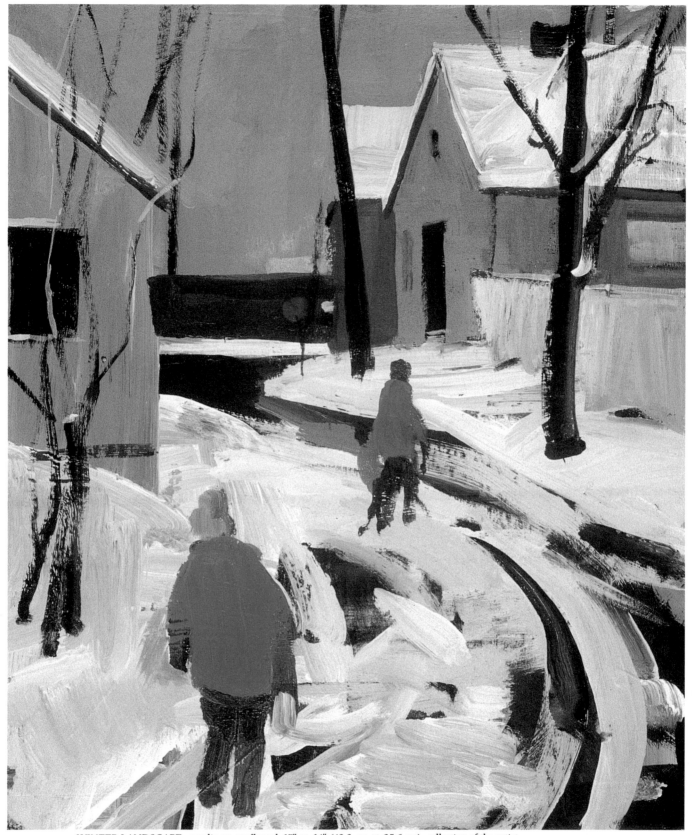

WINTER LANDSCAPE, *acrylic on cardboard, 17″ × 14″ (43.2 cm × 35.6 cm), collection of the artist*

Step Seven. *Completed the scene by adding more branches with snow, reshaping the snow on the ground, and finishing the figures. Again, I kept the scene loose and free, without a tight rendering of details. After all, there is something light and free about a snow-covered landscape.*

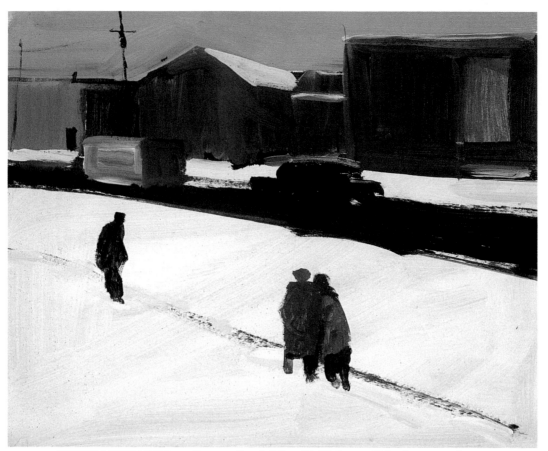

WINTER LANDSCAPE I, *acrylic on cardboard, 14″ × 17″ (35.6 cm × 43.2 cm), private collection*

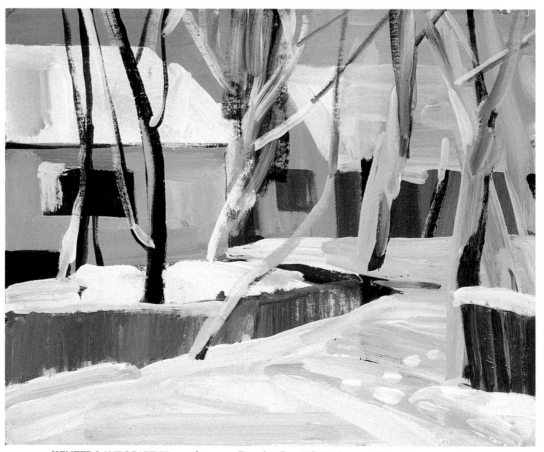

WINTER LANDSCAPE III, *acrylic on cardboard, 14″ × 17″ (35.6 cm × 43.2 cm), private collection*

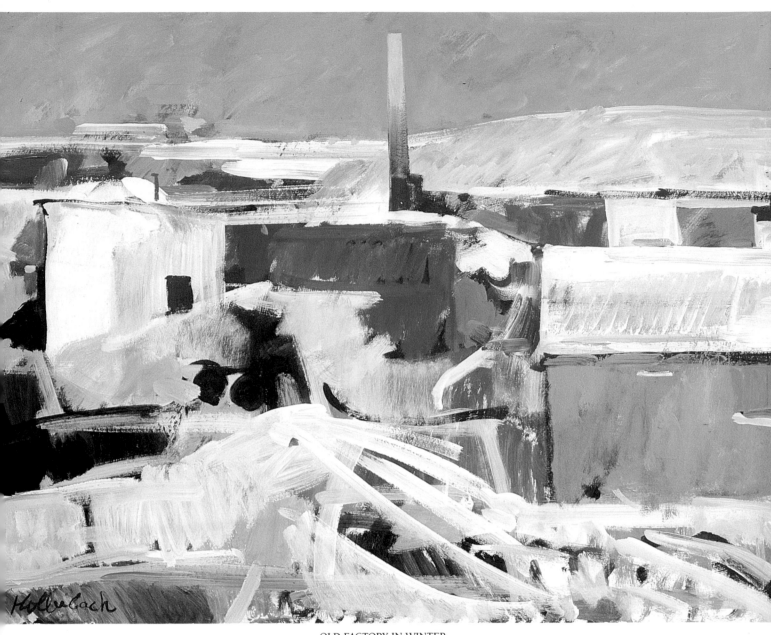

OLD FACTORY IN WINTER
acrylic on illustration board,
30″ × 40″ (76.2 cm × 101.6 cm),
courtesy Newman & Saunders Galleries

ACRYLICS OUTDOORS

When winter ends and you're struck by the urge to be outdoors, the landscape can seem especially promising as subject matter for a painting. Before you venture out with your acrylics to paint *en plein air*, it helps to know how the medium will behave. ❧ Knowing how quickly acrylic paint dries, some artists are reluctant to take it outdoors for fear the pigments will harden before they have a chance to start painting. These fears are largely unfounded. Of course, if you squeeze colors on your palette and then spend thirty minutes making your preliminary drawing, warm air and breezes will cause the paints to form a thick film that you'll have to puncture to get to the moist layer underneath. Or, your colors will dry out altogether. In other words, you have to be quick working outdoors. Don't put paints on your palette before you've done the drawing. If you draw with a brush, squeeze out just one color and work with it. When you're ready to paint, squeeze the pigments out in small amounts only as you need them, not the full range. Use more water than you would when working indoors. And watch your brushes! Don't let them get hard—dip them in water often. Drybrush effects are risky outdoors, so stick with a thick alla prima technique. Rinse your brushes thoroughly when you're done and give them a little

additional cleaning when you get home. Wash them with soap and water just to make sure there is no paint left on them. ❧ In spite of these precautions, the advantages of painting outdoors with acrylic colors by far outweigh the risks. Working fast, you can produce two or three landscape sketches a day and store them immediately. Just think how careful you'd have to be with wet oils! ❧ Outdoor landscape painting is a kind of ritual. It requires solitude, concentration, and being in tune with oneself, but has all the thrills of travel and adventure. You should prepare your tools carefully. In my case these are a small, portable French easel, paints and brushes, a few gessoed cardboards (or canvasboards or canvases), a knapsack holding a disposable palette, a flask of water, a small jar of gesso (oh, how good it is outdoors, so smooth and liquid— no thinning with water needed!), rags, and a bucket for water. When I find a good location, setting up is easy: disposable palette in front, jar of gesso and water bucket in the middle, tubes of paint laid out in back on the handy wocden palette that comes with the easel. ❧ How do you find a good spot to paint? A common practice (but one that I don't follow myself) is to use a small cardboard mat as a viewfinder, framing parts of the landscape in it to find a pleasing angle and arrangement of elements. It certainly works, but is rather mechanical and doesn't allow you to expand your view. It is better, I believe, just to assess the situation and compose with your eyes. In searching for a place to paint, I follow the same principles of composition I outlined earlier: balanced weight and diagonal energy forces that counteract one another. In practical terms, when I see a strong vertical element—a tree, the corner of a house with one side lit, the other in shadow—a road at an angle, and something—a fence, a bush—on the other side, I've got a composition. In my mind I see a simple abstract sign or a letter—X, U, H, or Y—that approximates the skeleton of this landscape. That's all I need to sustain the painting's momentum.

A VILLA IN CANNES

For a number of years I have spent my summer vacations on the Côte d'Azur near Cannes. It is a beautiful countryside, one that Matisse, Picasso, Bonnard, and Chagall all interpreted during stays there at one time or another. Although their art makes one feel very humble, the temptation to paint your own southern French landscape is great, and I confess that I succumbed to it. I have found that it's better to let your surroundings influence you than to impose your personality on them; and the longer you stay in a particular place, the less resistance you'll have to its influence. ❧ In a park in Cannes there is a luxurious villa that once belonged to the Rothschilds. Surrounded by palm trees and pines, this gracious building, now a municipal library, served as the focus for several of my paintings. The park itself is a paradise for painters who use acrylics or other water media, because every twenty to thirty yards there is a water faucet sticking up from the ground—obviously for the gardener's use, but what a joy for artists! ❧ Each of the three views of the park shown here was an attempt to catch that specifically southern light and the rich hues of the vegetation. The bright Mediterranean sun forces you to use strong, contrasting colors—almost the primary colors of red, yellow, and blue.

The First View. *For the first landscape in this park I chose a simple spot with a tree on each side, a house in the middle, and a garden path forming a diagonal from left to right—a compositional arrangement in the shape of the letter U or O. Self-explanatory steps show the progress of this painting.*

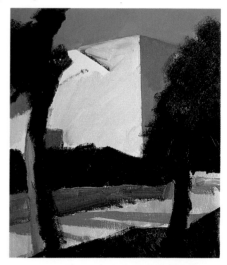

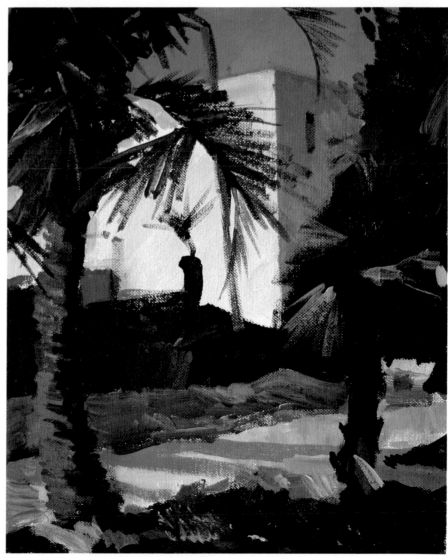

VIEW FROM THE GARDEN, CANNES, *acrylic on canvasboard,*
14″ × 11″ (35.6 cm × 27.9 cm), courtesy Newman & Saunders Galleries

The Second View. *Later I shifted my attention to the villa itself. Not being very good at precise architectural rendering, I decided to paint the villa as seen through the trees. The dark windows formed in my mind a kind of pattern, a grid that would be the skeleton of this painting. It took me an hour and a half to paint it, my usual span of time for an outdoor landscape.*

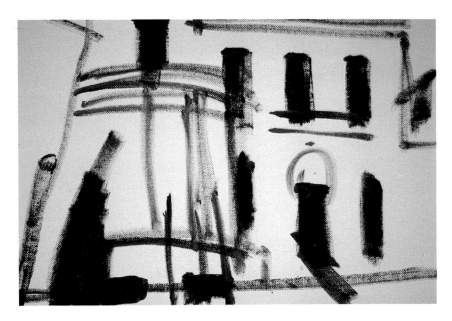

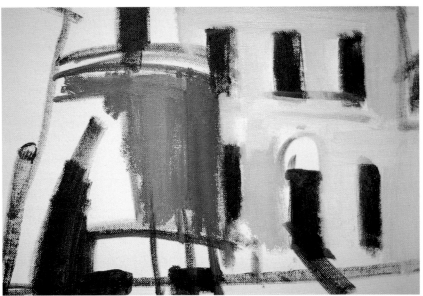

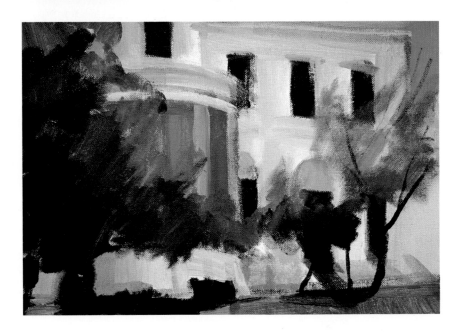

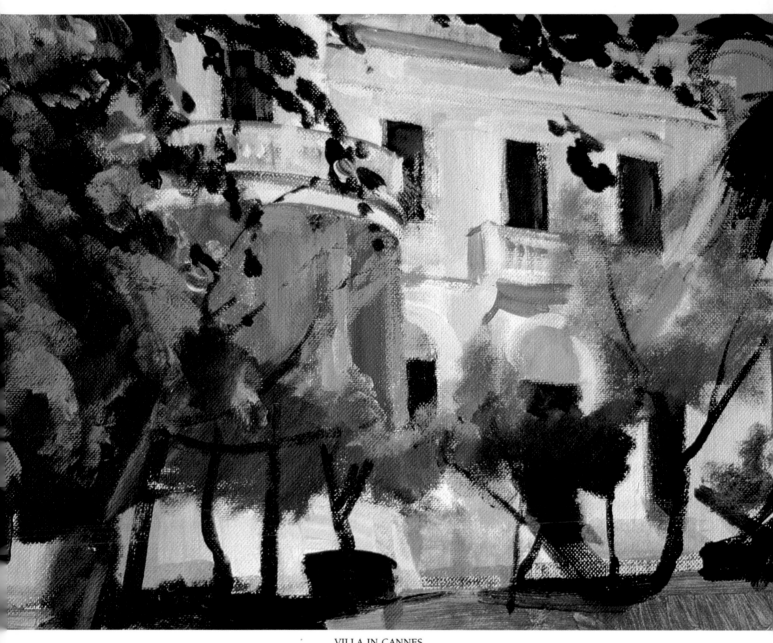

VILLA IN CANNES
acrylic on canvasboard,
11″ × 14″ (27.9 cm × 35.6 cm),
courtesy Newman & Saunders Galleries

The Third View. *It was not yet noontime and I felt like taking another shot at the villa, another corner of it.*

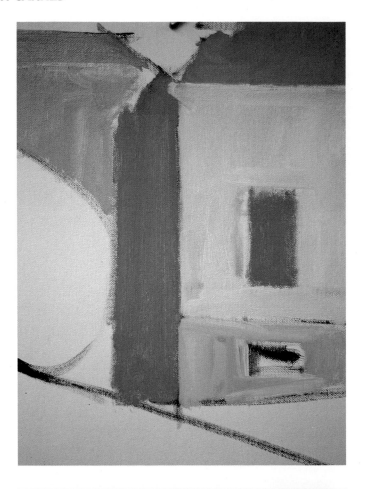

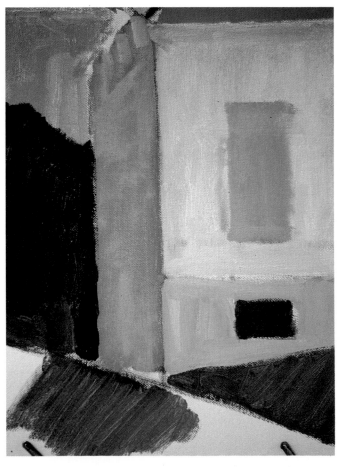

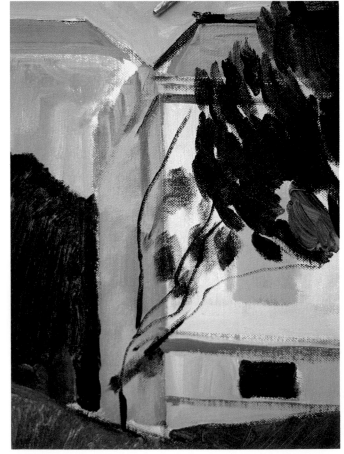

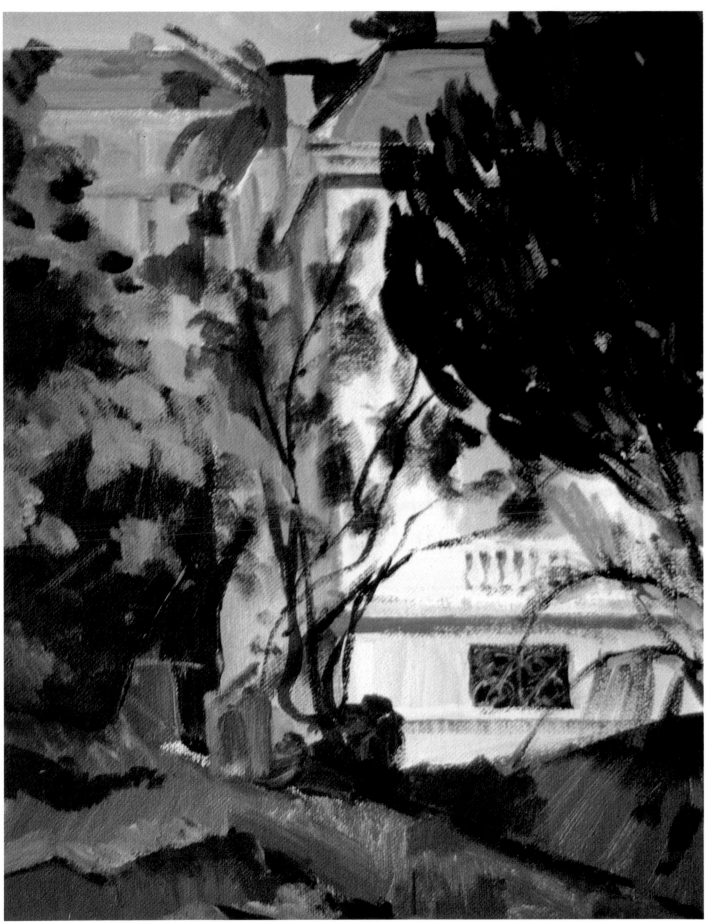

CORNER VIEW, VILLA IN CANNES, *acrylic on canvasboard, 14″ × 11″ (35.6 cm × 27.9 cm), courtesy Newman & Saunders Galleries*

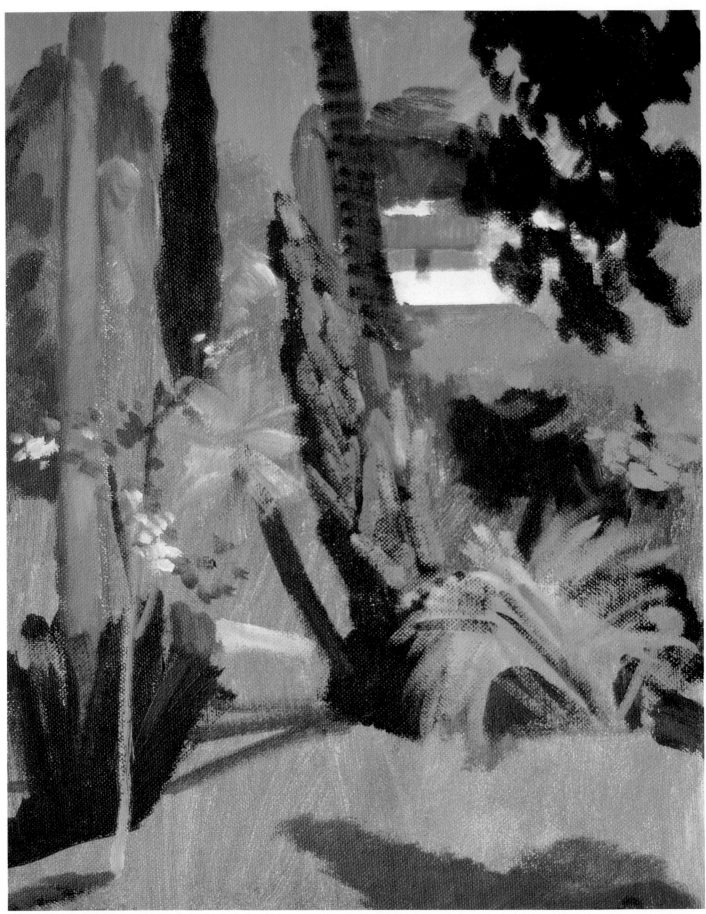

GARDEN, CANNES, *acrylic on canvasboard, 14″ × 11″ (35.6 cm × 27.9 cm), courtesy Newman & Saunders Galleries*

PAINTING SUNLIGHT

When painting sunny landscapes I strictly follow the rule of warm light and cool shadows. What is this and how does it work? No elaborate color theories are necessary; intellectualizing the process of painting might only prevent the artist from developing an individual and natural color sense. So let me present just a few simple thoughts on color and its "temperature."

As we all know, the three primary colors are red, yellow, and blue. All other colors are combinations of these three. Red and yellow, the colors of fire, are warm and blue is cool, like water or sky. In reality there is no such thing as pure red, pure yellow, or pure blue. They are all slightly intermixed. A primary color acquires the warm or cool characteristic of whatever color is added to it. For instance, a touch of yellow added to blue will make it greenish and warmer; a touch of blue will make it more bluish and cooler. When you're painting a landscape, it works like this: The sun's warm rays make all lit objects warm in color, while in shadow the same color appears as a cooler and darker shade. Remember—on a hot, sunny day you stay in the shade to be cool. When there's no sun, the opposite is true—the light is cool and shadows are warm. When you're cold you go into a covered, shaded area for warmth. On another day in the garden in Cannes I did this quick sketch. The strongly vertical and slanting trees in the foreground formed a fencelike

grid for the composition, and I used a little white house with a red roof in the distance as the focal point. In this picture the sunlit side of the house is painted in warm colors—yellow-white for the wall, cadmium red for the roof—while the part in shade is done in cool gray. The grass is warm yellow-green in the sun and cool bluish green in shadow. In the color chart reproduced here, I have made two columns with four colors in each—white, yellow, red, and blue. On the left side the light is cool, the shadows warm. The right side shows the same colors as they would appear in sunlight, with cool shadows. The difference is deliberately made subtle but is still noticeable. In reality these contrasts are often quite strong. Study paintings by

Edward Hopper, for instance, or by the French impressionists. The important thing in landscape painting is to stick to one of these principles and not mix them up. Otherwise your painting will have no convincing light, no true atmospheric condition.

Of course, there are days when the sun is hiding behind thin clouds that let some of its rays filter through, and other days when passing clouds darken the landscape for a few minutes. Then all of a sudden the sun comes out, but illuminates a different part of the landscape. What do you do? Well, you have a problem here! The only solution is to stick to the light condition you started with and follow through by memory using one of the cool-warm color systems and never mixing the two.

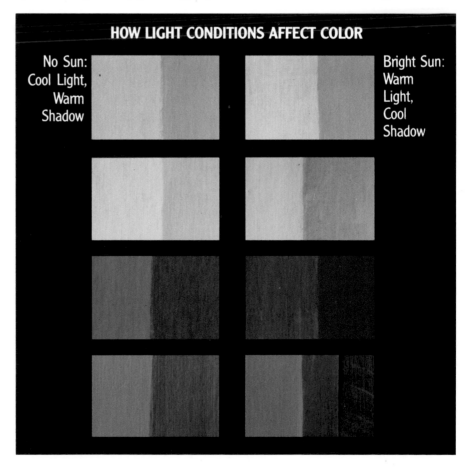

HOW LIGHT CONDITIONS AFFECT COLOR

No Sun: Cool Light, Warm Shadow

Bright Sun: Warm Light, Cool Shadow

PAINTING SUNLIGHT

Houses are very helpful reference points when you're studying the effects of light on the landscape. Out the window of my hotel in Le Cannet, north of Cannes, I could see many houses in the distance; below is a view I painted when the sun was at its brightest. I recommend that you try, as I then did from another vantage point, to paint the same houses several times by different light, as shown on the facing page. Warm light and cool shadows appear in both the morning and late afternoon renderings of this landscape, but from different angles.

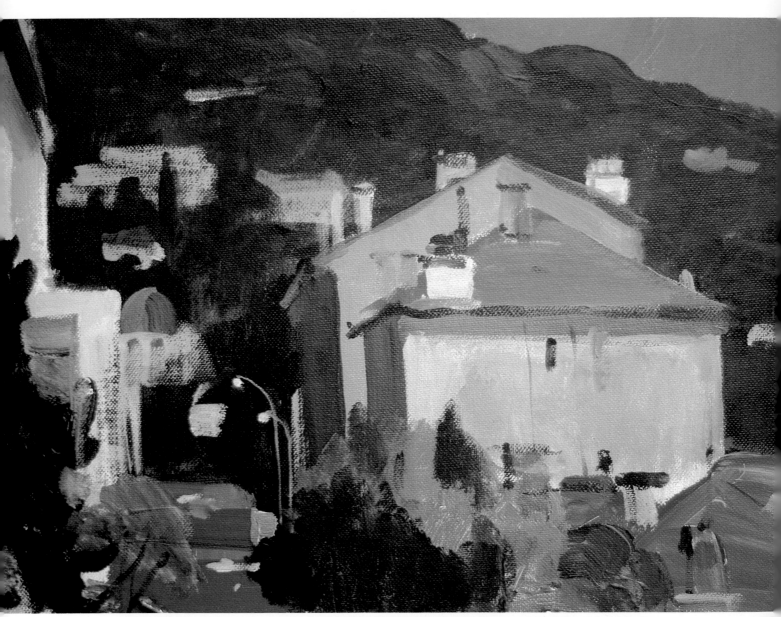

VIEW OF LE CANNET, *acrylic on canvasboard, 11″ × 14″ (27.9 cm × 35.6 cm), courtesy Newman & Saunders Galleries*

Some sunlit houses do not show much of a shadow on the side, but glow brightly from the front against the dark trees and hills in the background. You have to treat them as if they were bright abstract shapes on a dark background. Their luminosity and color make the forms project in space, creating perspective.

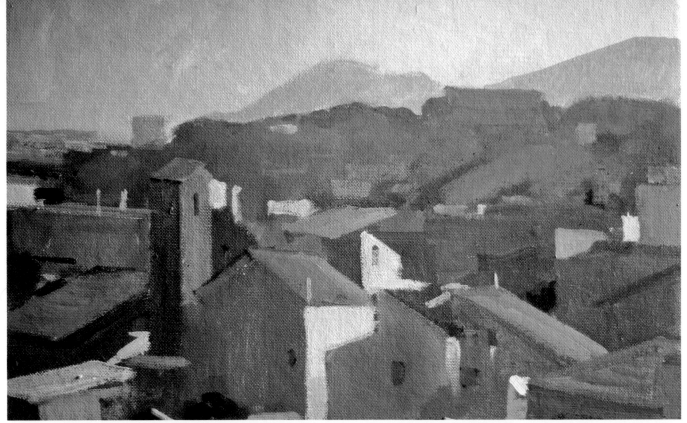

VIEW OF CANNES, MORNING, *acrylic on canvasboard, 10½″ × 16″ (26.7 cm × 40.6 cm), courtesy Newman & Saunders Galleries*

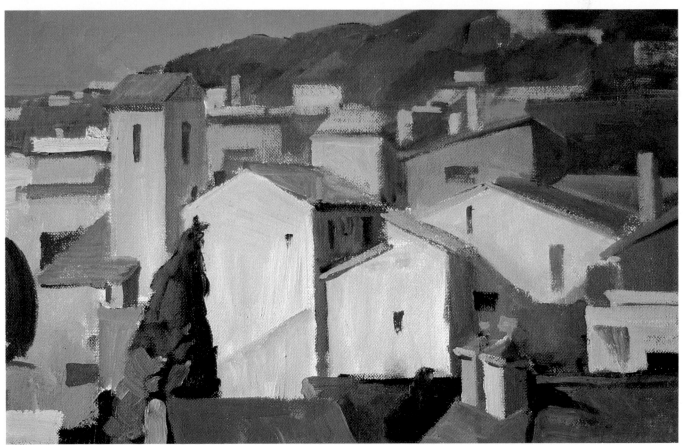

VIEW OF CANNES, EVENING, *acrylic on canvasboard, 10½″ × 16″ (26.7 cm × 40.6 cm), courtesy Newman & Saunders Galleries*

At top is the painting I made in the morning; this one I did in late afternoon. In composing the scene I disregarded some large houses and palm branches that were in the foreground of my window view and brought forward, as if by telescopic lens, only the houses in the distance. I added a light-colored chimney on the right, a few more windows on the houses, and small buildings in the background.

PAINTING FOLIAGE One day I decided to tackle green foliage, something I do not always like to do, preferring larger and harder shapes. But the Cannes garden offered a tempting variety of trees, including palms. It would be cowardly to skip painting palms just because they have already been painted by so many excellent artists. So I did one.

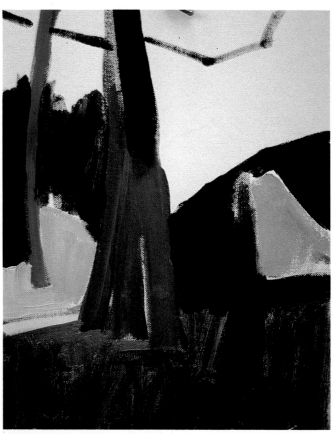

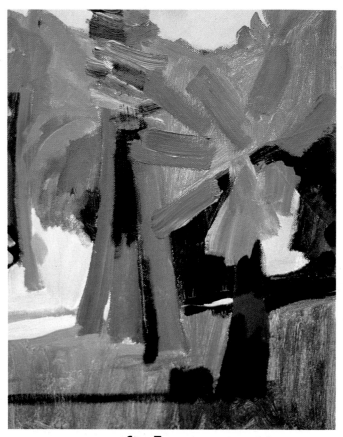

Step One. *I started as usual with a hard, semiabstract skeleton.*

Step Two. *Then I proceeded to block in green masses.*

Step Three. *After that I started to design the foliage, trying to see abstract patterns in different kinds of trees.*

Step Four. *The result was rather conventional, but what can you do? Paint the same view six or ten times and you are bound to do it slightly differently in each try, a little more boldly, perhaps, with stronger colors. One simply cannot repeat the same thing the same way.*

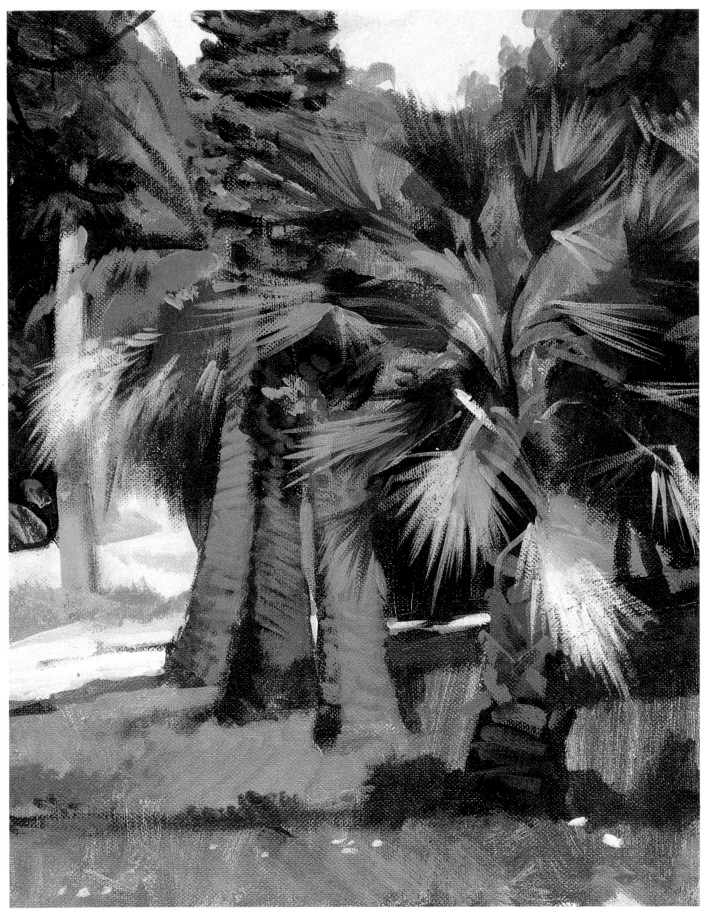

GARDEN TREES, CANNES, *acrylic on canvasboard, 14″ × 11″ (35.6 cm × 27.9 cm), courtesy Newman & Saunders Galleries*

57

ADDING PEOPLE AND CARS TO SCENES I wanted to do a few street scenes with people, keeping their light or dark shapes as simple as possible. People come and go, and you have to memorize their shapes and colors. But you can and should change them to fit your composition. It's very important to do their heads right; better they should be somewhat small than too large, since figures with large heads look like children. Leg length is crucial, too. Clumsily done big-headed, short-legged figures look funny and resemble midgets. This painting with the pink house didn't present much difficulty; all steps followed smoothly one from the next. I kept the figures small and clearly delineated the shape of the trees. Notice how cool the purplish shadow is against the sunlit yellowish ground.

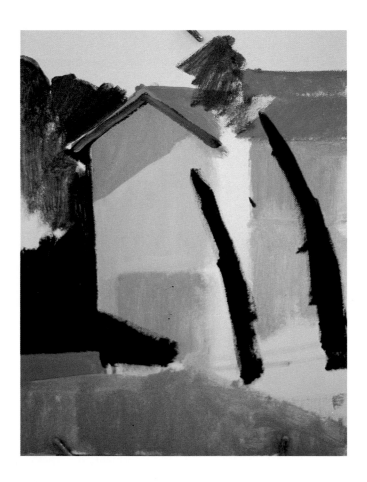
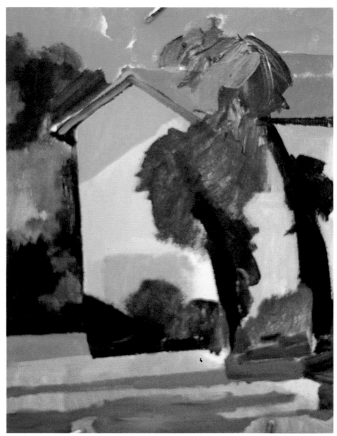

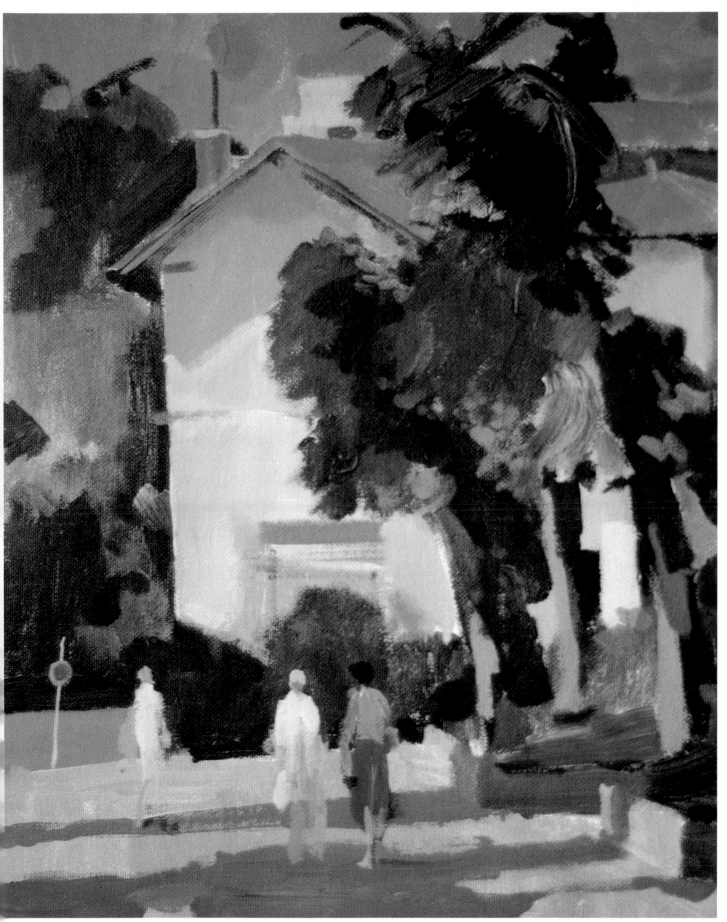

STREET IN LE CANNET, *acrylic on canvasboard, 14″ × 11″ (35.6 cm × 27.9 cm), collection of the artist*

ADDING PEOPLE AND CARS TO SCENES

In this painting with two houses I had to face the problem of moving cars. What do you do when a parked car that looks so good where it is suddenly drives away, leaving the street empty? Or when three or four cars and a truck come by and block your view? Well, you have to put up with it and do your best. Your ability to memorize shapes—not only of human beings, but cars, too, will help. In the first two stages the street appears empty. Actually, it was full of people and moving cars, but I had to get the big areas down. When I was ready to put people and cars in, there was a lull. Then came a lonely figure in black, and I eagerly put her down. Soon after that a big delivery truck drove up but was too big to fit. After adding and eliminating people and cars for a while, I ended up with one shiny car and several small figures (the lady in black left—that is, I painted her out). All my cars are "generic"; they are of no particular make, model, or year and aren't European, American, or Japanese. Of course, I could use photos to make them specific, but that's not important to me. How the shape of a car fits into my painting is my concern. And if the car is a mongrel, so be it.

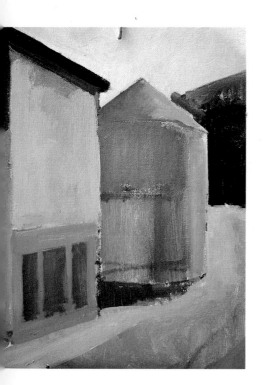 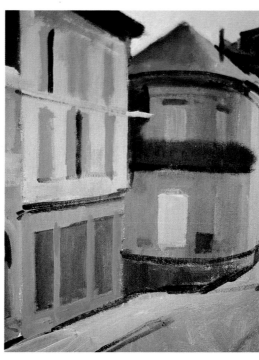

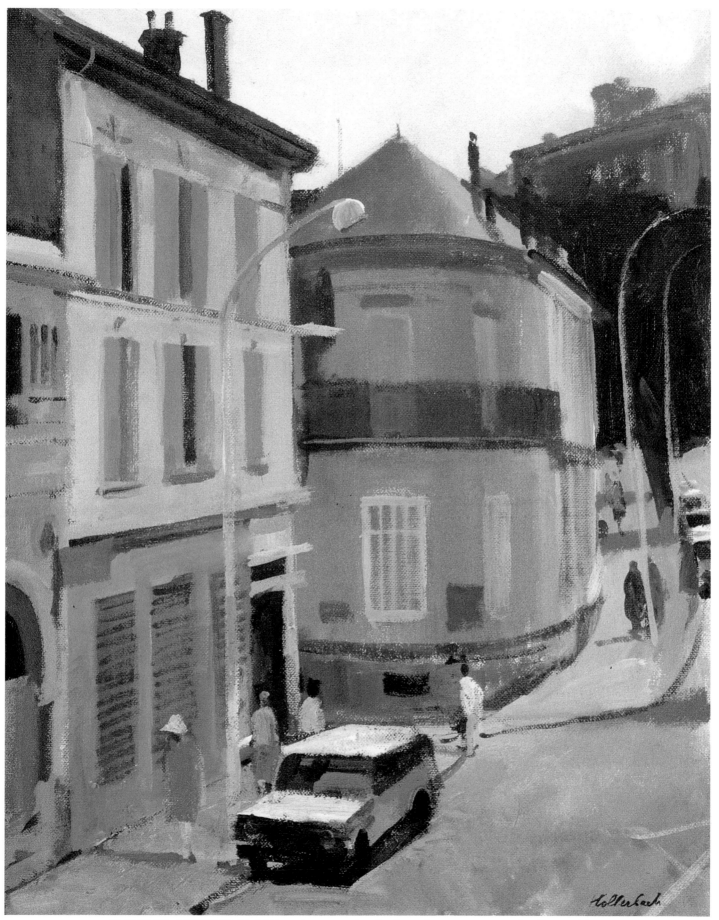

BOULEVARD CARNOT, LE CANNET, *acrylic on canvasboard, 18″ × 14″ (45.7 cm × 35.6 cm), collection of the artist*

61

ADDING PEOPLE AND CARS TO SCENES

As I said near the beginning of the chapter, artists usually paint landscapes according to season, and autumn is no exception. Figures seen against the turning leaves particularly attract me. When you add figures to a fall composition, try to keep them from competing with the colorful foliage or getting lost in its midst.

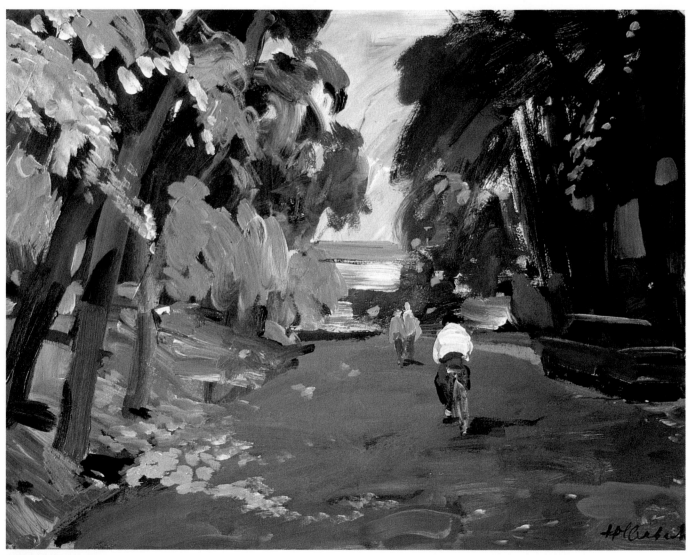

EARLY AUTUMN
acrylic on illustration board,
19½" × 25½" × (49.5 cm × 64.8 cm),
courtesy Newman & Saunders Galleries

SUNNY DAY IN THE FALL
acrylic on illustration board,
25½" × 19½" (64.8 cm × 49.5 cm),
courtesy Newman & Saunders Galleries

62

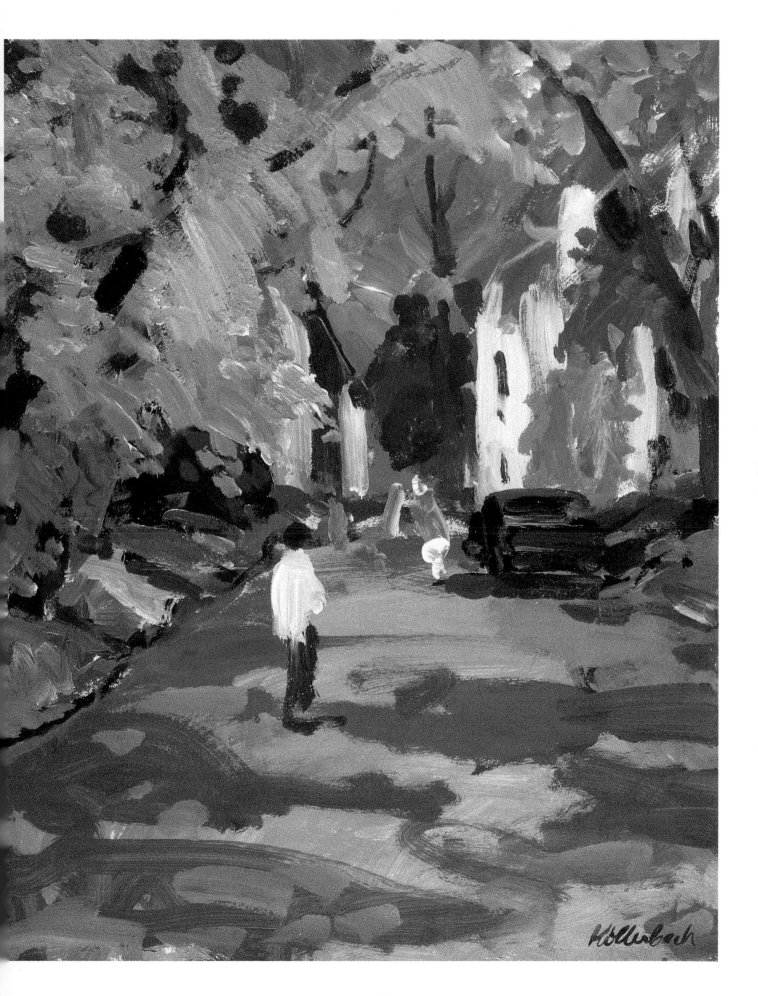

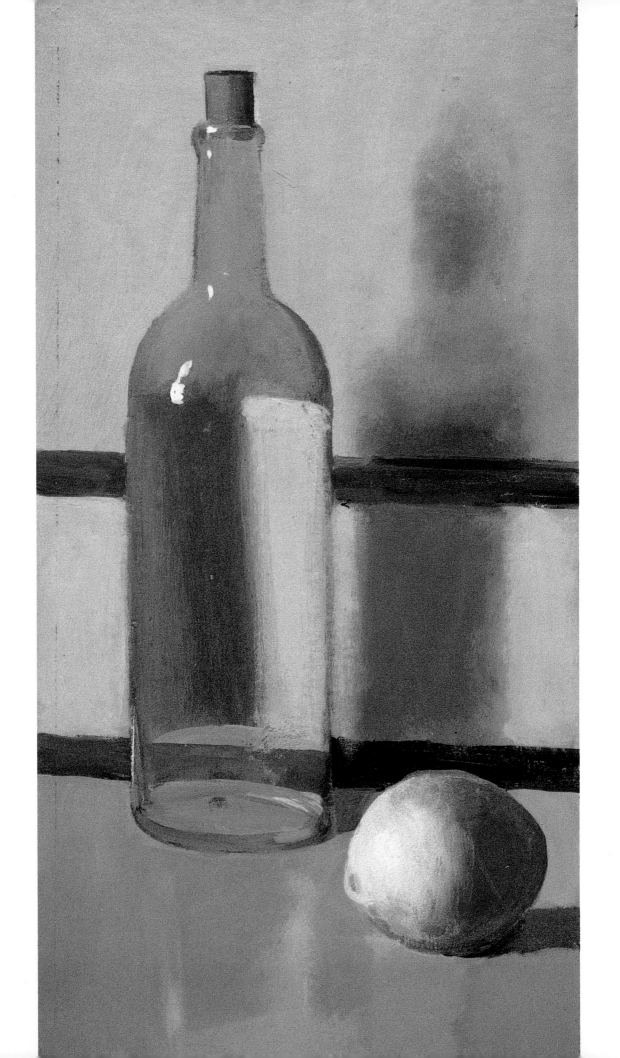

PAINTING STILL LIFES

For quite some time after I left art school, I didn't touch still life at all. I was, you see, into "bigger things" such as figure composition. While deeply respecting the Dutch school of still life painting and admiring Cézanne, I thought nevertheless that still life was for those who had a special predisposition toward it, people who usually don't paint figures. And my first love was, and still is, the figure. ❧ Yet one learns and matures. Psychologically, young people are "on the go" and often pay little attention to objects. Older people, on the other hand, have more emotional attachment to things that have been silent companions in their lives. They see fruits and flowers as beautiful gifts from nature, things to capture and possess. Interest in still life does not stem from materialistic instincts, but from emotional, philosophical, and even poetic ones. And the comeback of still life in American art is a welcome sign. ❧ Being a humble practitioner of painting, I certainly do not ascribe all these noble notions to my own still lifes. I have a long way to go. All I wish to say is that still life means more and more to me as the years go by. ❧ The highly realistic, "touch me" type of still life that doesn't show much more than its own hyper-reality doesn't have much appeal for me. I always strive for something either dramatic or plain and simple. As for objects, I select whatever I might use in my figure compositions. Flowers rarely appear in my paintings, and I haven't done them often; glasses, bottles, jars, fruits, and vegetables are more common.

BOTTLE AND LEMON
acrylic on cardboard, 15½" × 7½" (39.4 cm × 19.0 cm),
courtesy Newman & Saunders Galleries

A QUICK IMPASTO STILL LIFE

When I am feeling fairly ambitious about doing a still life, I arrange objects carefully. In this case I was in the mood for a quick impasto painting, so I set my pace accordingly, working rapidly but surely.

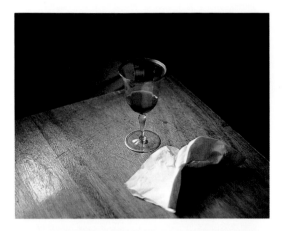

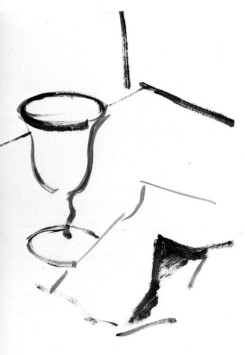

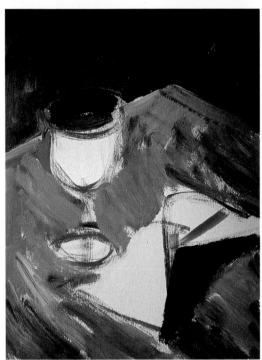

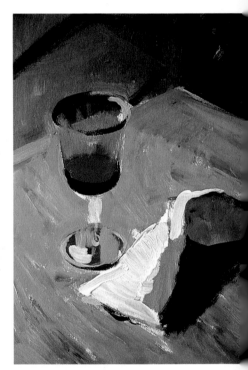

Step One. *I began by doing a rough drawing with a brush to capture this simple setup of a wine glass and napkin.*

Step Two. *Next I blocked in dark areas. As you'll notice, the glass was not drawn correctly in the first step and has lost its shape even more in the second. But this is no problem; because acrylics are opaque, I can easily restate the shapes in the next stage.*

Step Three. *Now I can paint the glass and napkin more carefully, watching all values and colors.*

Step Four. *In this step I had to correct the shape of the glass, add highlights and reflections, and adjust the background, which thus shaped the napkin. The diagonal line at the top now runs parallel to the table, while in reality, as the photo shows, it slanted upward. I changed it because I thought there were too many angles going in different directions.*

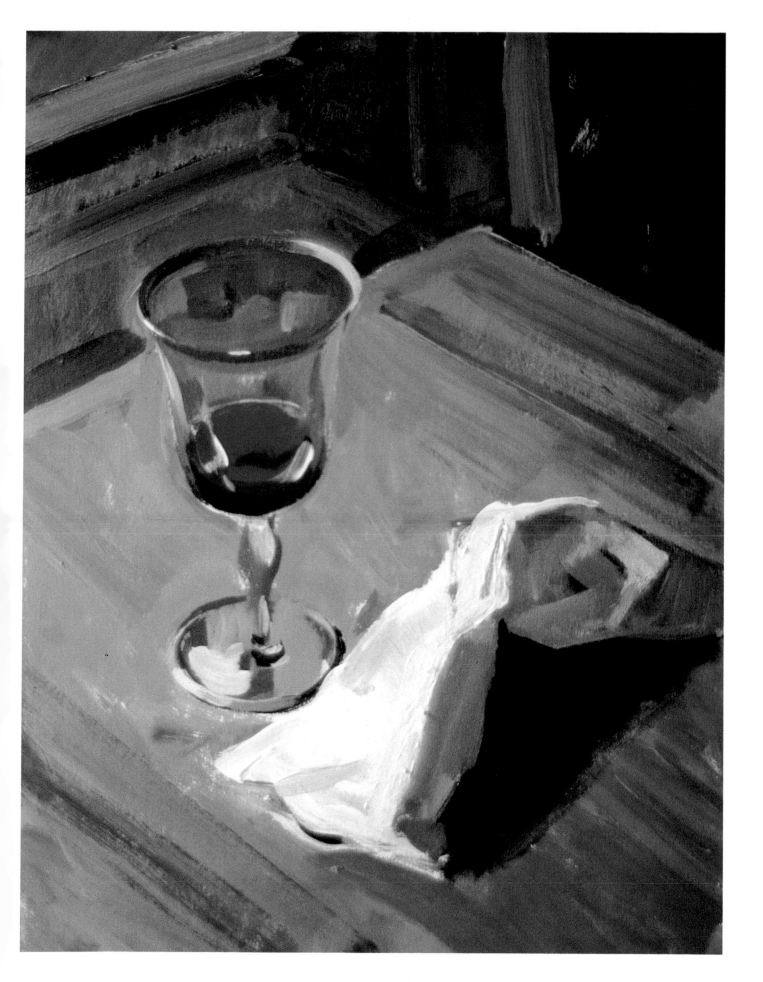

THE EFFECTS OF STRONG LIGHT

I set up this composition with potatoes, a head of purple cabbage, and cutting board near a window where the various objects would receive direct light so I could study its effects on them. What intrigued me most were the design of the cabbage leaf and the bluish reflections on top of the table, the play of cool but strong light coming from the window. I like strong light because it forms a good pattern and gives a painting clear structure.

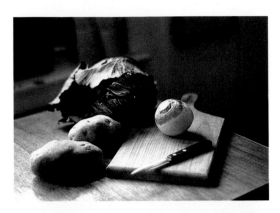

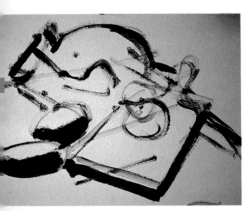

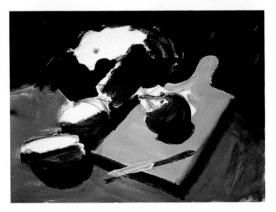

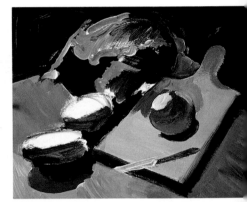

Step One. *I always do the initial drawing roughly, with a medium-size bristle brush. There is no point in making the drawing precise, since it's only going to be covered later; when working in acrylics you move and superimpose paint so rapidly that a detailed preliminary drawing rarely pays off. Usually I do the drawing in a warm, dark earth color like umber or sienna, but any color will do, because unlike oils, acrylics won't bleed into whatever is painted over them.*

Step Two. *Values are extremely important in holding a composition together. When blocking in the colors I used strong, bright tones that were slightly darker than the colors I actually saw, because I wanted their intensity to show through the layers of paint applied later. In that respect acrylics are similar to oils. To produce the feeling of strong light, value contrasts also must be quite strong. Often I leave light areas blank (white) for that purpose and paint them in later.*

Step Three. *What gave this still life its atmosphere and provided the key to the whole setup were the light hitting the cabbage leaves and the purplish reflection the whole thing threw on the table. I mostly used dioxazine purple, phthalo blue, yellow ochre, raw sienna, alizarin crimson, burnt umber, Hooker's green, and some black in this painting. Like most artists, I don't premix exact colors on my palette, but try the approximate hues right on the painting and then add whatever I believe is needed.*

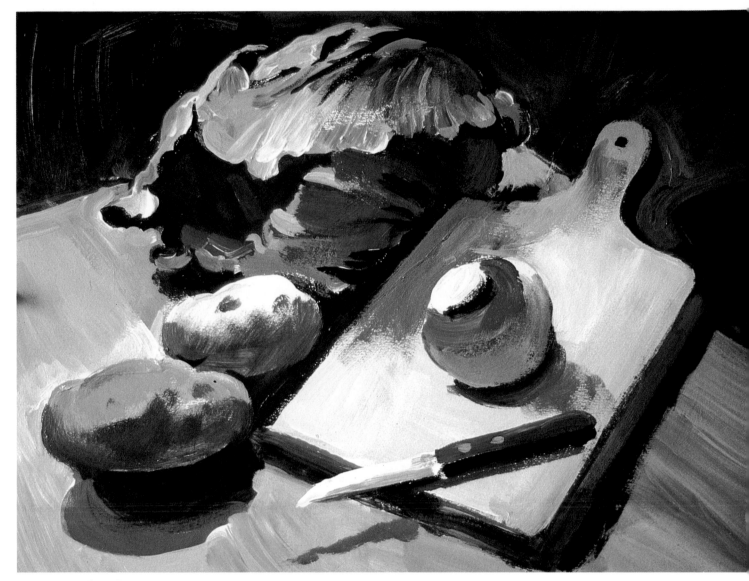

Step Four. *Here I made the finishing touches, designing the shapes more precisely and adding reflected colors and highlights. I paid particular attention to the different textures, creating the rough surfaces of the cabbage and potatoes by dragging a brush over them and making the turnip appear smooth with wet-in-wet blending. When this still life looked complete in terms of color and value, I stopped, even though some details might have been worked out better. I didn't want to ruin the freshness of the image by taking it to a more finished state. Overworking a painting may kill it, perhaps even more in acrylics than in oils.*

PAINTING REFLECTIVE SURFACES

Some still lifes take much more time. I didn't know what I was getting into when I set up what I believed to be a simple still life of a coffee mug, salad bowl, and cocktail glass. The choice of objects reflects my daily routine; these are indeed my silent companions. 🕭 This painting was a confusing struggle for me. Reproducing all the steps here wouldn't be very instructive, since most adjustments were very subtle, but suffice it to say that there were many hits and misses along the way. My guiding principle was to keep the light cool, since it was a gray day, and the shadows warm. If I hadn't aimed for consistency in handling the light conditions, my still life would have disintegrated into unrelated color areas. However, the maddening thing was that some reflections and shadows, instead of appearing warm the way they should have, looked cool! The reason, I believe, was the changing light, clouds, and a shimmer of warmth in the sky that penetrated my narrow kitchen window. 🕭 Final advice: When doing still lifes in acrylics, you're better off with impasto and drybrush techniques. Use dramatic lighting, paint freely, and avoid unnecessary subtleties—unless you want the challenge. I suggest that you undertake this kind of picture only if you like grappling with jigsaw puzzles. Set up some dishes on a shiny surface, and good luck!

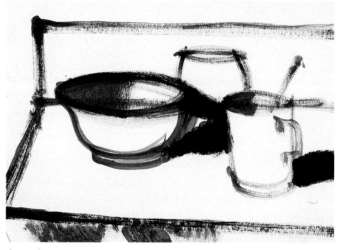

Step One. *In the drawing I deliberately slanted the edge of the kitchen table, since running it parallel to the bottom of the board would look too repetitious.*

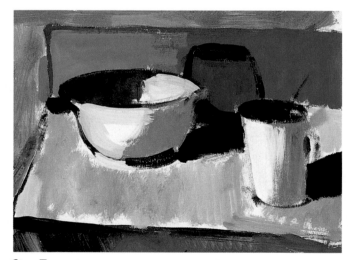

Step Two. *Blocking in the colors was easy.*

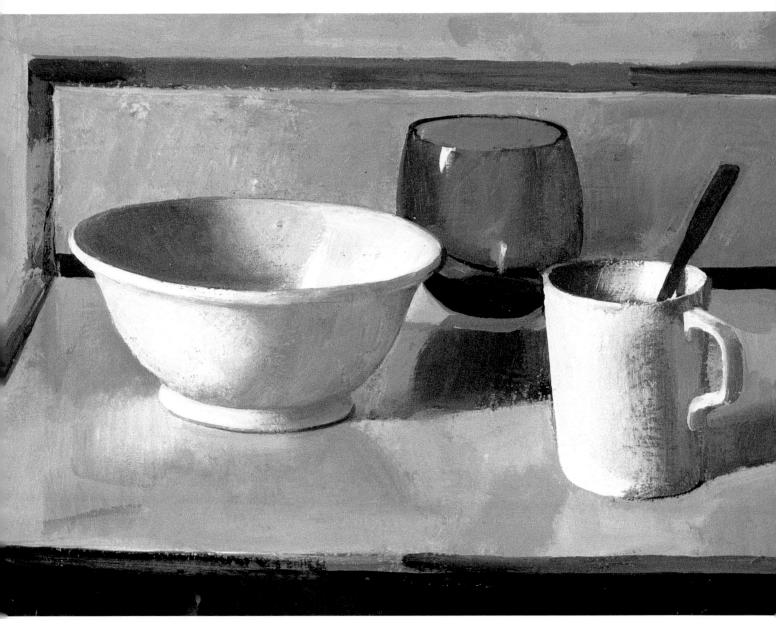

STILL LIFE WITH GLASS, MUG, AND BOWL, *acrylic on cardboard, 9″ × 12″ (22.9 cm × 30.5 cm), collection of Mr. Adrian S. Hooper*

Step Three. *I kept just the big shadows on the bowl and mug warm and painted some very fine and delicate areas, particularly oval shapes and highlights, with a small, pointed sable brush (one made for oils, not watercolor). The problem arose in tightening the drawing and in reproducing the complex reflections on the shiny Formica table. I used all the tricks of blending, glazing, and drybrushing I could think of. I switched from a bristle brush to a big, pointed sable brush and tried rubbing in the shadows in a thick drybrush, then putting a wet wash over it. I struggled for hours and hours. One thing I learned well: Unless you have a special reason to do so, don't put a wet wash over paint that is not completely dry or you'll get a darker spot. This is an especially common blunder when you want to match a color. You think your match is perfect and you apply the paint as a semitransparent wash over an area that is not yet dry, only to discover that it dries as a dark blob! Most frustrating.*

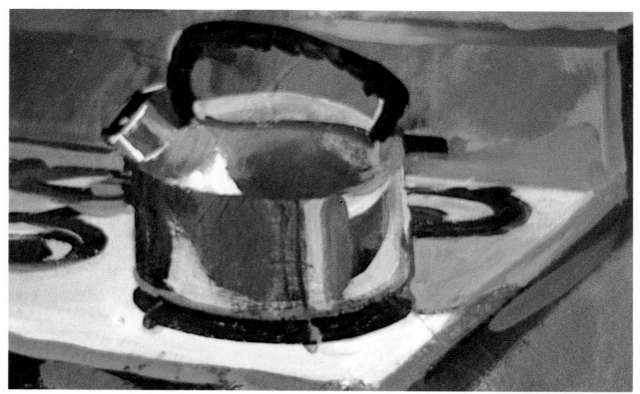

TEAKETTLE, *acrylic on illustration board, 5¼" × 8¾" (13.3 cm × 22.2 cm), collection of the artist*

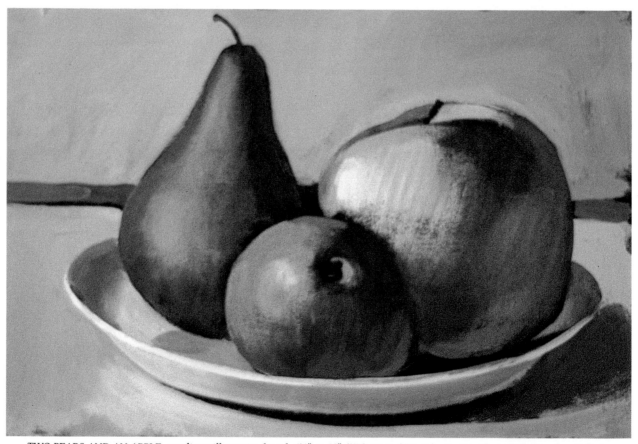

TWO PEARS AND AN APPLE, *acrylic on illustration board, 6¾" × 10" (17.2 cm × 25.4 cm), courtesy Newman & Saunders Galleries*

You'll have better luck with tricky situations if you practice on a variety of subjects. Here are a few more examples of reflective surfaces, each with a quite different texture. 🐚 When painting the teakettle I tried to see the hard, angular reflections it threw as abstract shapes. Capturing the light in *Two Pears and an Apple* was somewhat easier, as it was subtler and cast a gentle sheen on the fruits' skin. 🐚 One day passing a fish market I became fascinated by the silvery scales of the day's catch resting on glistening beds of ice. I tried to capture these quickly so as not to lose their freshness.

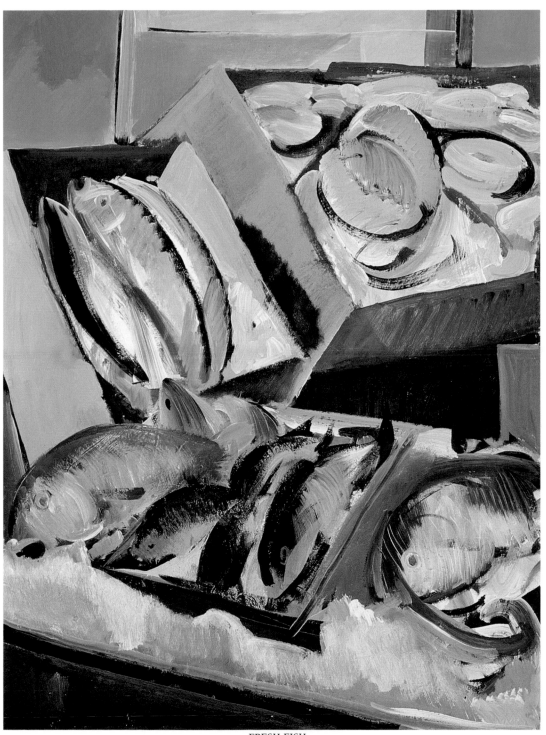

FRESH FISH
acrylic on illustration board,
40″ × 30″ (101.6 cm × 76.2 cm),
courtesy Newman & Saunders Galleries

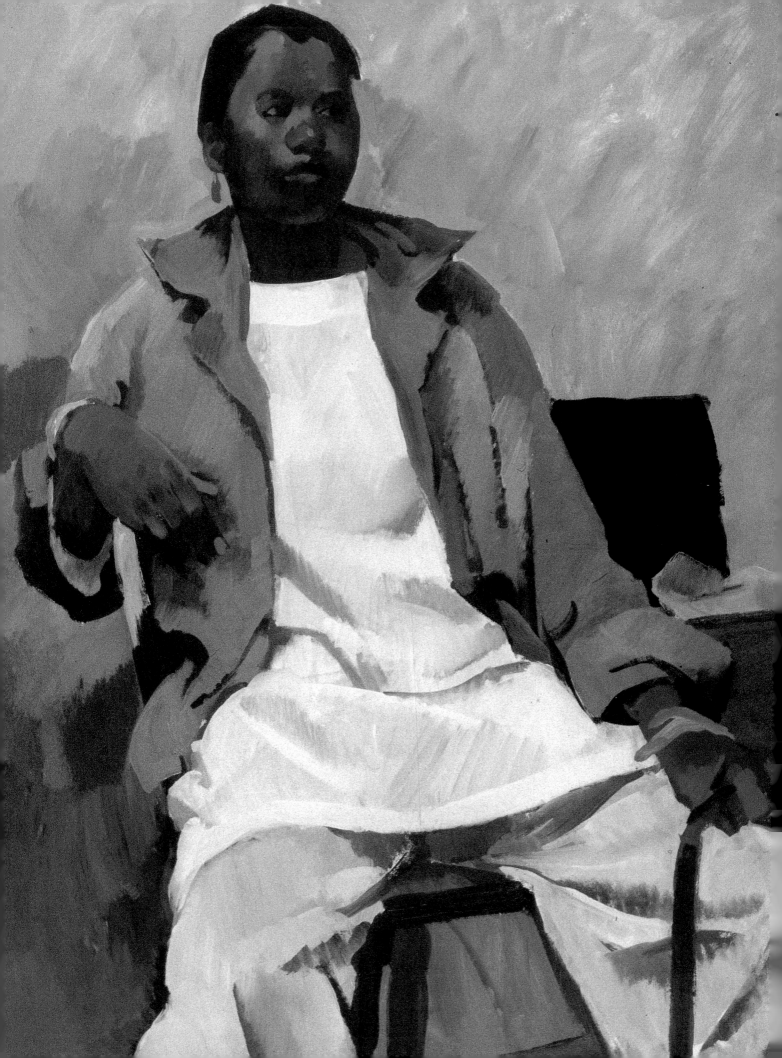

STUDYING HEADS AND FIGURES

To be quite frank, acrylics are not an ideal medium for portraiture; oils are much more suitable, for obvious reasons. Because acrylics dry so fast, they don't allow the artist to use the prolonged, wet-in-wet blending and gradual buildup oils permit. With acrylics you have to more or less hit it right from the beginning. This may be very frustrating for those who rely on slow, steady progress in painting, but the beauty of acrylics is that if you miss, you can immediately paint out what's wrong and start again. Each attempt is almost a new face.

Acrylics do lend themselves very well for what I call "head painting." While a portrait in oil is a highly ambitious, complete work of art, a painting of a head is a simpler, more casual, but not necessarily less effective way to capture the character and mood of a person. Great artists painted not only portraits, but also heads that often were studies for large figure compositions. Acrylics, I repeat, are excellent for such studies; these look best when you do them quickly with sure brushstrokes, using impasto and drybrush but little blending or glazing. Acrylics keep you on your toes because they force you to move fast, and speed is often very beneficial in art. When you have no time to work your painting to death, an old truth becomes most apparent: Quick sketches are more often than not better, more expressive, and individualistic than so-called finished drawings. The same is true with painting heads and figures in acrylics. If you are ready to try, this is what I suggest. Do not make a careful charcoal or pencil drawing of a head; it's a waste of time, because you are going to lose it soon. Instead, draw with your brush, using any dark color you wish. Tell yourself from the beginning that you are doing not a portrait, but a study of a head. Start with rough shapes and draw as you paint, trying to maintain strong value and color contrasts.

BLACK WOMAN
acrylic on illustration board, 40″ × 30″ (101.6 cm × 76.2 cm),
collection of the artist

A TYPICAL HEAD STUDY This Latin-American girl was a model in the art school where I teach. I dressed her up in what I thought might pass as a Latin-American costume, a colorful ensemble with lots of shadows so my students could learn to paint contrasts.

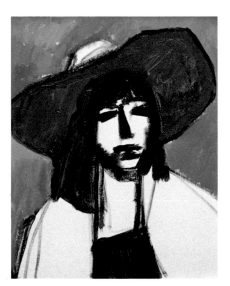 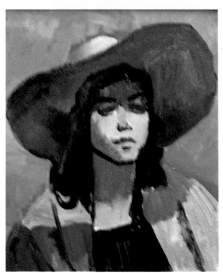 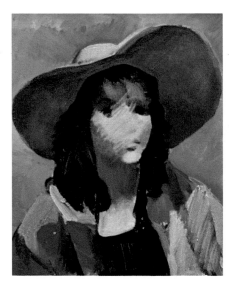

Step One. *I started with very rough, even sloppy drawing, painted the background, and put in shadows.*

Step Two. *Here I developed the color contrasts. My rendering of the model's face looked too narrow, so I also corrected the drawing at this stage.*

Step Three. *At this point, had I been more successful in getting the model's likeness, I could almost have stopped and just refined some areas—her neck, the side of her face, her shawl—and added some realistic touches here and there. But in my painting the face of this very pretty girl lacked character. I had to paint it out.*

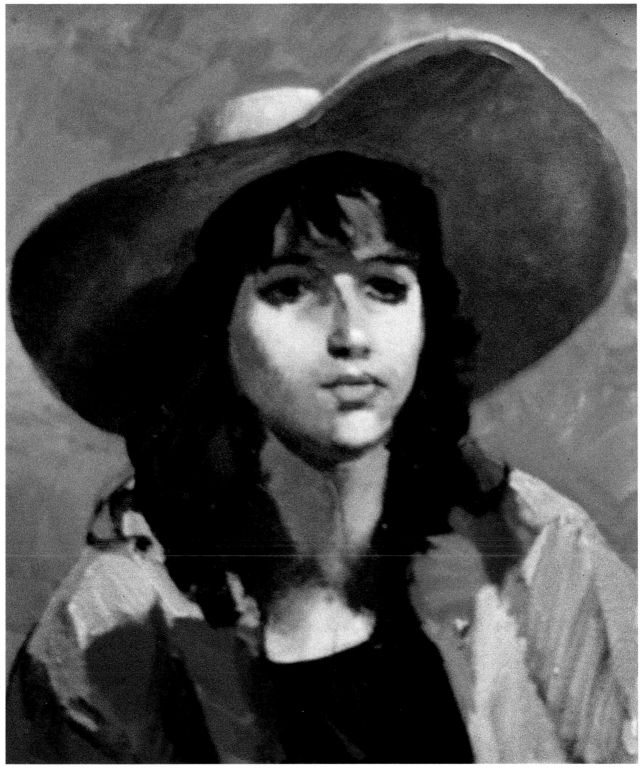

MARCELA, *acrylic on canvasboard, 20" × 16" (50.8 cm × 40.6 cm), collection of the artist*

Step Four. *The new face, I was sorry to notice, while better than the first one, was still too conventional and without spark. But the time for the demonstration was up. I thought of not including this head in the book at all—why show the reader your weaknesses? But paintings that develop perfectly step by step, that are so nice and clean that everything just falls neatly in its place, yielding striking results, are not what really happen in an artist's studio. My old teacher used to pick out a student's weakest painting and say, "That's where you really stand! Anyone can paint a good picture once in a while, but it's how low you can sink that's the true measure of your achievement—or lack of it!" Tough talk, but I still remember it. Your painting didn't work out as well as it should have? So what. You have learned something. Do another one.*

HEAD STUDIES FROM MEMORY Painting heads and figures from life is only part of my "head painting" activities. Since the main body of my work consists of figure compositions done from memory, I practice painting heads this way, too. To collect ideas, I always carry a small sketchbook with a black cover (a disguise that makes it resemble a prayer book and doesn't advertise me as a sketch artist) so that I can draw heads in pen and ink wherever and whenever I want, using a Pentalic Mark X fountain pen or Pilot Razor Point felt-tip pen. Often I just memorize them, noting color and value contrasts—yellow-red bald head, dark curly hair, white shirt; or, long blond hair, red face; or, pink face, white-gray beard, and so on. Back in my studio I refer to the sketchbook or to my visual memory and do them in acrylic. *Head of an Old Man*, reproduced on page 21, was such a memory study, as were the heads in this series of back views.

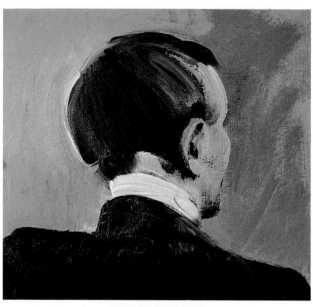

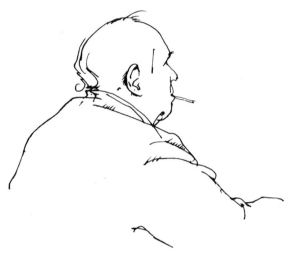

MAN IN GRAY SUIT
acrylic on illustration board,
14" × 15" (35.6 cm × 38.1 cm),
collection of the artist

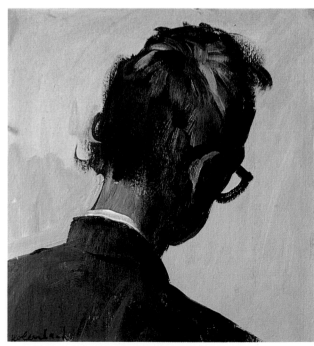

MAN IN BLUE SUIT
acrylic on illustration board,
14" × 15" (35.6 cm × 38.1 cm),
collection of the artist

In this typical head study, first I made a rough drawing from memory and blocked in the darks. Next I added color and value contrasts and corrected the drawing, making the neck thicker and the top of the head rounder. Finally I sharpened the details, adding highlights and the stripes on the man's shirt. These were originally very thin pinstripes. They looked too much as if they'd been drawn on top of the fabric, so I grayed down the shirt, then took a clean flat brush, dipped it into the gesso jar (I love doing this!), and applied paint in thick brushstrokes from the shoulders down. Whether a shirt like that was ever designed, who knows? It looks more like a pajama top. But the thick stripes brought the man's back forward and added the necessary freshness to the sketch.

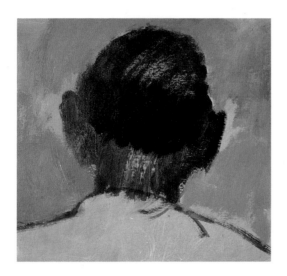
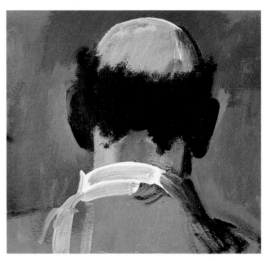

BALD MAN, *acrylic on illustration board, 14″ × 15″ (35.6 cm × 38.1 cm), courtesy Newman & Saunders Galleries*

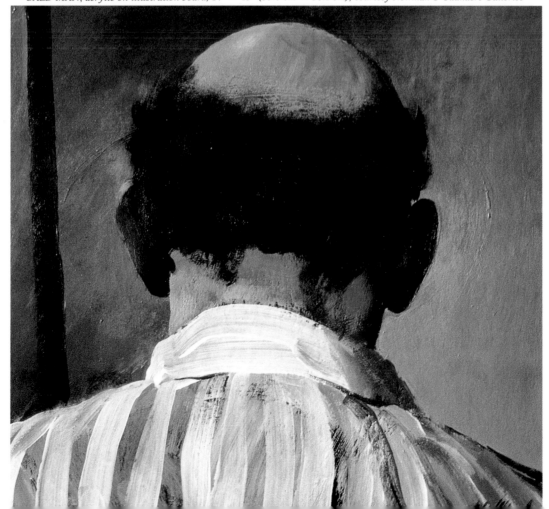

A REPERTOIRE OF FACES

Here are some more of the heads I've done. They might be based on reality, but sometimes they're imaginary—that is, you start with no idea of what kind of a head you're after and let your brushstrokes show you the way. It's great fun; you feel like a magician conjuring images from a vast, mysterious and invisible world of figurative possibilities.

❧ The secret of capturing features, especially in profile, lies in your ability to see distance and angles. The complexity of all the angles and shapes in a human face can seem intimidating, but becomes less so if you think in terms of simple geometry. Analyze a face by comparing such things as the slant of the forehead to the slant of the nose, the direction of the tip of the nose in relation to the line of the mouth, and so forth. Don't forget to notice how the mass and shape of the hair relate to the area of the face. ❧ Sketching people continuously will help you develop a quick eye. Start slowly with a linear drawing and try to speed up. In painting, create flat areas that have shapes and angles forming a face. Use just four color areas—background (dark or light), face, hair, and clothing. See how many faces you can do of people you have seen or imagined. Even if you are not a figurative painter, such exercises will do you a lot of good, sharpening your perception of colors and values. I often use the paints left over on my palette at the end of the day for this.

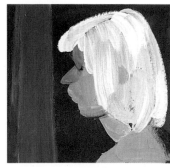

PROFILE OF A GIRL
acrylic on cardboard,
8" × 8" (20.3 cm × 20.3 cm),
collection of the artist

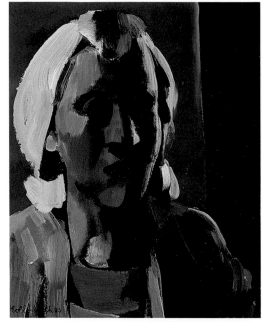

BLOND WOMAN
acrylic on illustration board,
15" × 12" (38.1 cm × 30.5 cm),
collection of the artist

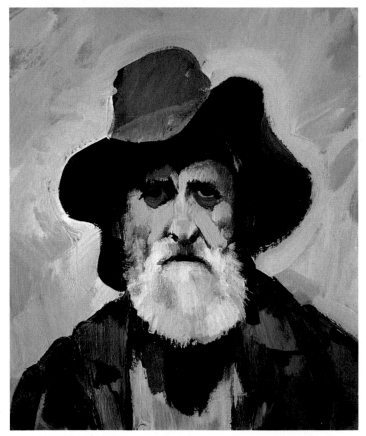

MAN WITH GRAY BEARD
acrylic on illustration board, 17" × 14" (43.2 cm × 35.6 cm),
collection of the artist

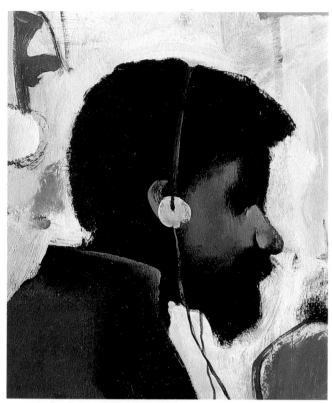

MAN WITH EARPHONES
acrylic on illustration board, 15″ × 12″ (38.1 cm × 30.5 cm),
courtesy Newman & Saunders Galleries

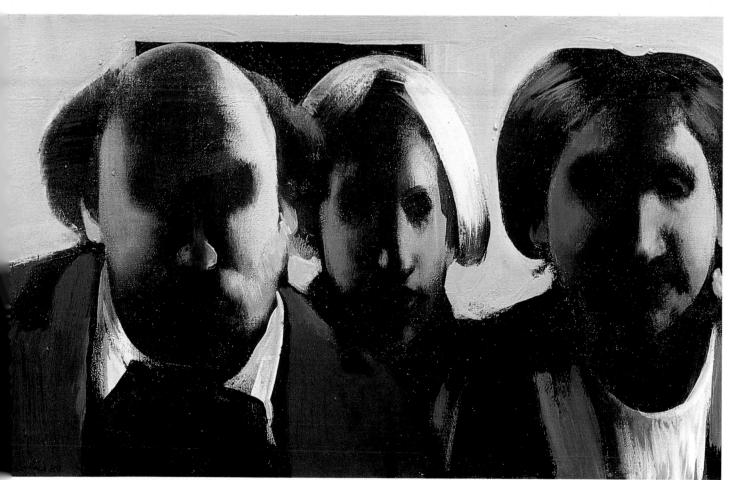

THREE HEADS (FAMILY), *acrylic on canvas, 12″ × 20″ (30.5 cm × 50.8 cm), courtesy Newman & Saunders Galleries*

81

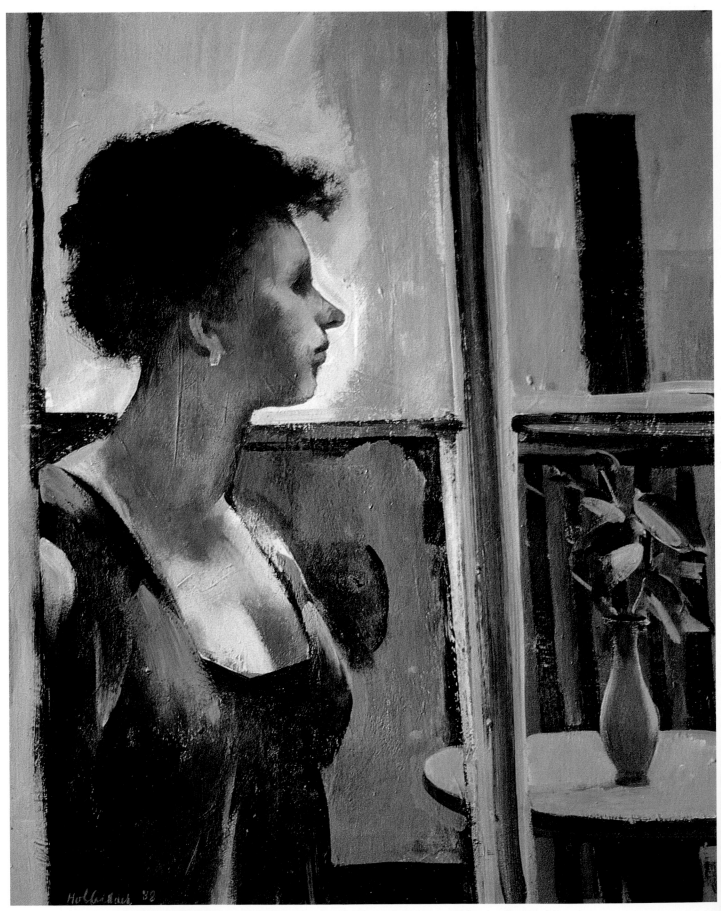

WOMAN WITH VASE, *acrylic on illustration board, 28" × 22" (71.1 cm × 55.9 cm), collection of the artist*

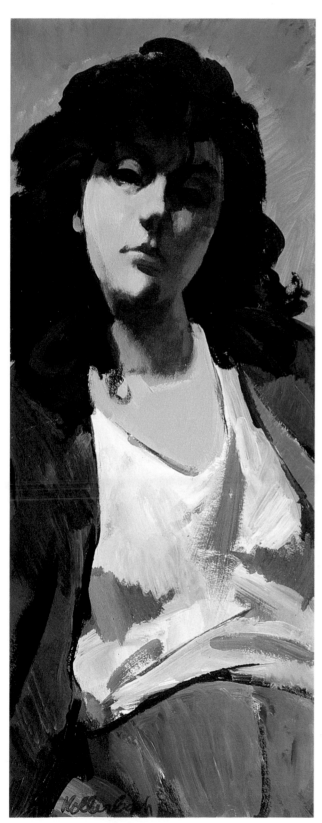

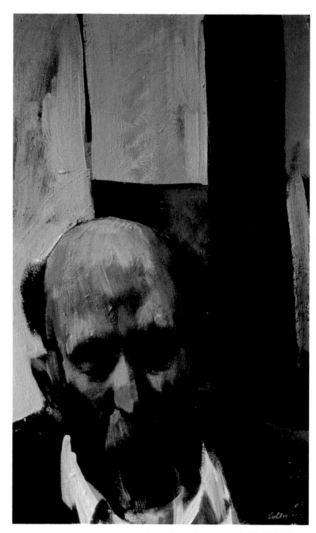

BALD MAN WITH BEARD
acrylic on cardboard,
21″ × 12½″ (53.3 cm × 31.8 cm),
collection of the artist

GIRL IN WHITE BLOUSE
acrylic on cardboard,
30″ × 11½″ (76.2 cm × 29.2 cm),
collection of the artist

SOME FIGURE STUDIES

The figure paintings on these two pages were also done in school at various times as demonstrations for my students. "Do as I do, not only as I say" is my motto for teaching. Each demonstration lasted about two and a half hours and resulted in varying degrees of success. As always, I stressed contrasts and a bold application of paint. 🖌 I do not consider these figures as portraits but as "heads with figures"—casual and sketchy, and typical of what acrylics bring to the subject.

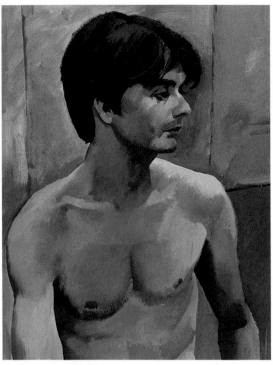

HEAD OF A YOUNG MAN
acrylic on illustration board,
22¾" × 17¾" (57.8 cm × 45.1 cm),
collection of the artist

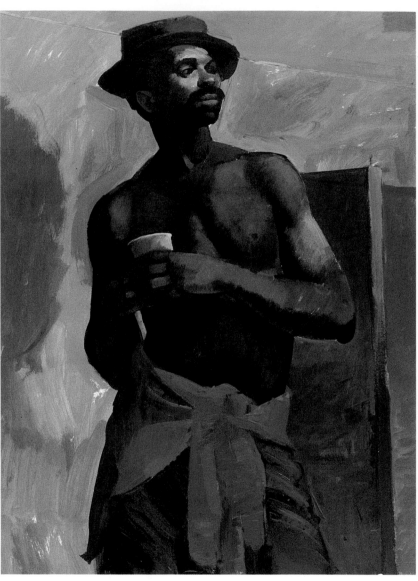

BLACK MAN WITH A BLACK HAT
acrylic on illustration board, 40" × 30"
(101.6 cm × 76.2 cm), collection of the artist

Unlike oils, acrylics behave slightly differently under various weather conditions. On hot, dry days they obviously dry very quickly. But on rainy or humid days like those that occur so often along the Eastern seaboard, the paints absorb the air's moisture and dry much more slowly. On these days you should try subtler blending and stay away from very heavy impasto; the paint won't dry for twenty to thirty minutes, and even then it remains tacky. Adjust your technique according to the weather to go along with Mother Nature, not resist her. Head of a Young Man was done on a wet, rainy day, which made the paint more malleable. Because I could push the paint more easily, closer tonalities and subtler variations of color were possible.

I painted this black man with a hat to demonstrate to my students the variety and richness of colors that exist in dark skin. Pinks, oranges, reddish browns, purples, and dull blues were deliberately accentuated in this study. Although oils are generally preferred for lengthy nude studies, using acrylics in this case prevented the colors from becoming the brownish mess that is so common when depicting dark skin in oils. I emphasized contrasts in value and used wet-in-wet blendings on the shoulders and chest, heavy impasto on the red cloth, and loose brushstrokes in the background.

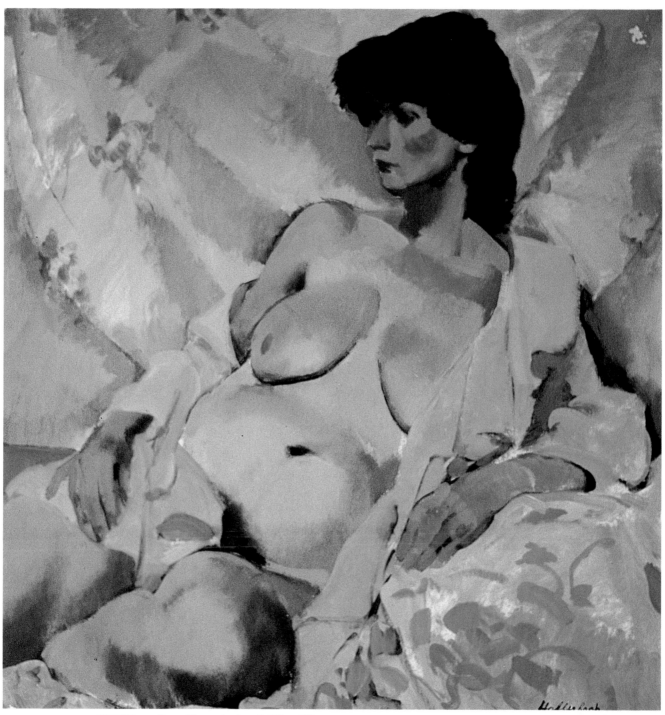

NANCY, *acrylic on illustration board, 32" × 29"*
(81.3 cm × 73.7 cm), courtesy Newman & Saunders Galleries

Painting this seminude woman reclining in an aqua-colored robe against pale blue patterned pillows presented a unique set of challenges. Although very close in value, her body was definitely reddish, while the cloth in the background was yellowish. I made a mental note to keep that difference at all times. There were few value contrasts within each area of color, and the modeling had to be subtle. Acrylic colors do permit a variety of subtle tones, but you can't achieve the same softness oils make possible. A nude painted in acrylics has more pronounced, more definite shapes. I used wet-in-wet blending and drybrushing into wet paint on the torso to achieve softness, and created slightly sharper modeling on the folds of the cloth.

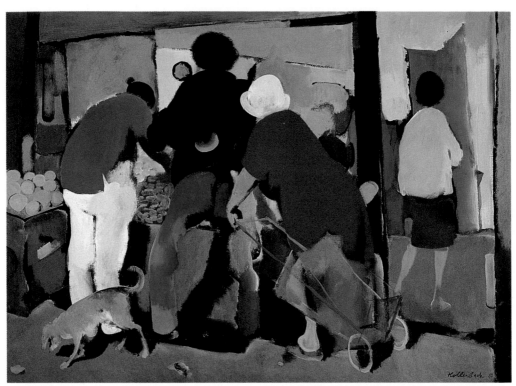

UPPER BROADWAY MARKET, *acrylic on canvas, 30" × 40" (76.2 cm × 101.6 cm), private collection*

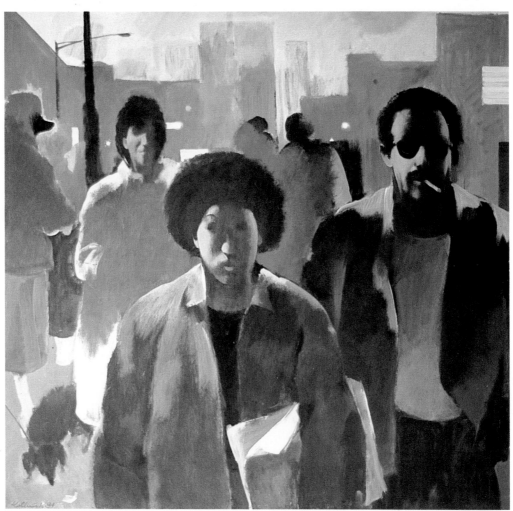

CITY PEOPLE, *acrylic on board, 40" × 40" (101.6 cm × 101.6 cm), courtesy Newman & Saunders Galleries*

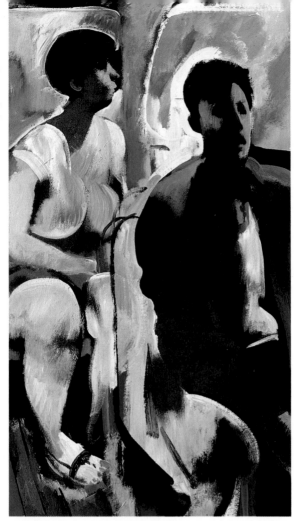

BUS RIDERS
*acrylic on illustration board,
40″ × 20″ (101.6 cm × 50.8 cm),
courtesy Newman &
Saunders Galleries*

FOUR SUBWAY RIDERS
*acrylic on illustration board,
40″ × 40″ (101.6 cm × 101.6 cm),
collection of Mr. and
Mrs. Paul Hondros*

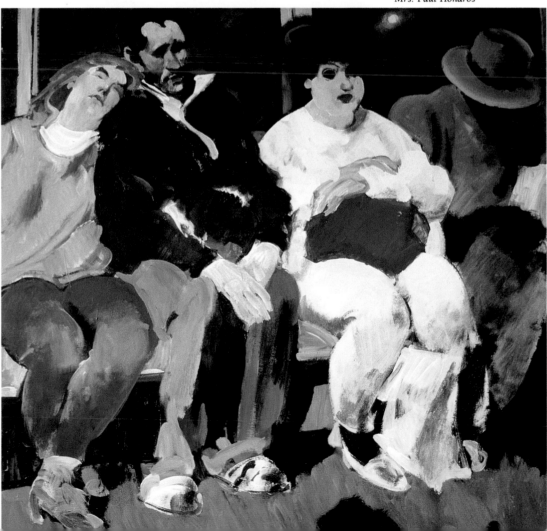

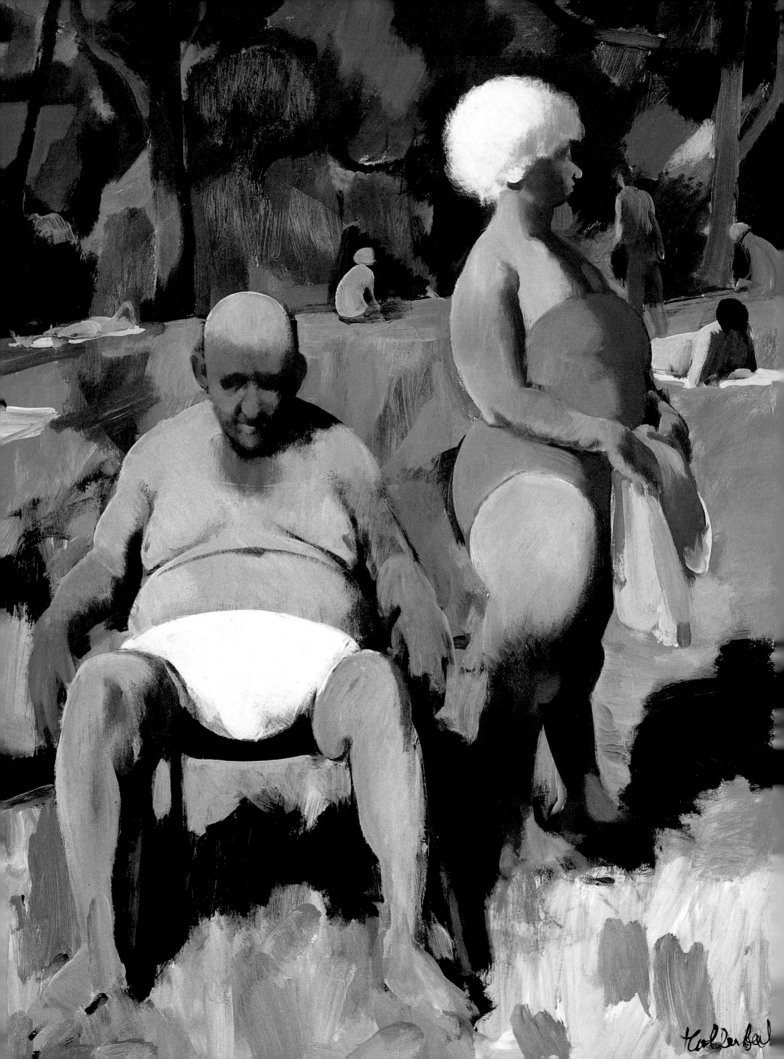

COMPOSING FIGURE PAINTINGS

Before I discuss at length how to put together paintings with many figures in them, I would like to share with you some more of my ideas on composition. Beyond the basic principles of weight, balance, and directional energies I've already discussed, what about figures themselves? How does an artist create and group them together to make the overall composition work? Quite obviously you can place a number of figures on the canvas in good balance, but this won't keep them from looking stiff and posed. So how can you make them interesting in shape and movement? Are there any guidelines for making them look alive? ⁊ Of course. The best practice, known to all artists for ages, is to sketch people on the street or at home going about their everyday activities in order to study their gestures and shapes. Drawing anatomically correct nudes in art school, or even so-called action poses (how artificial most of them are!) will not help. You have to go out and observe people with pen or pencil in your hand. But even this is not enough. Back home you should play around with the figures you have sketched—create groups, rearrange them, add and eliminate some figures, all to gain practice in composing with them. ⁊ A few years ago the National Academy of Design in New York had a very informative exhibition of small paintings. All the same size, they had been done in the first half of the nineteenth century by students at the Ecole des Beaux-Arts in Paris who were competing for the Prix de Rome. In that competition, every student drew a lottery ticket that assigned a historical, biblical, or mythological theme and was given seventy-two hours to produce a small composition in oil without any supporting material and without leaving his cubicle. That was composing in the truest sense of the word! ⁊ Today we don't have to subject ourselves to such rigorous discipline, but composing from memory, with or without supporting materials, is, I believe, the most creative and demanding artistic activity. ⁊ So, armed with a pad and pencil, go out and sketch people.

SUNDAY IN THE PARK
acrylic on illustration board, 40″ × 30″ (101.6 cm × 76.2 cm),
courtesy Newman & Saunders Galleries

SKETCHING GROUPS OF PEOPLE We all have some skills in quick sketching and know how to express movement in line, skipping details. There is one thing, however, that you should always keep in mind when drawing groups of people, and that is the differences in their sizes and shapes. Sometimes these differences are not clear; for example, people standing together may appear to be of similar height, shape, and build. In such a case, you have to exaggerate their differences.

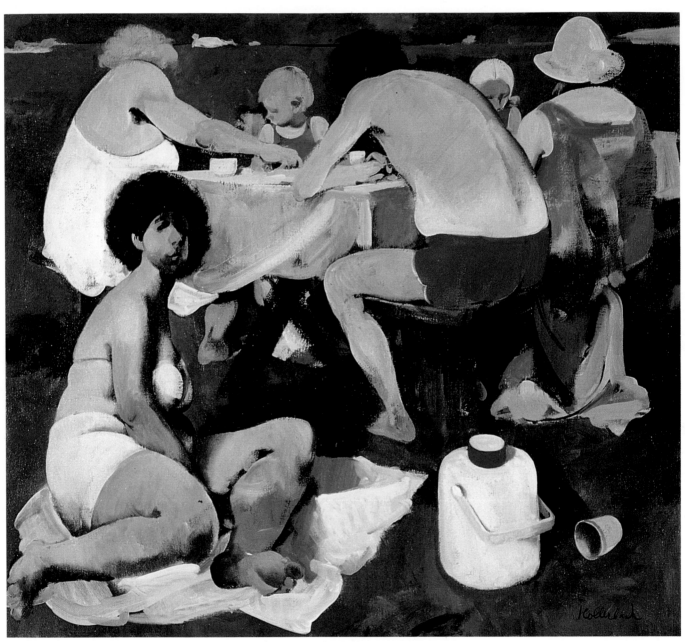

PICNIC
acrylic on canvas, 42" × 46" (106.7 cm × 116.8 cm),
courtesy Newman & Saunders Galleries

The best way to do this is to imagine them as simple geometrical figures—a rectangle, an oval, a triangle. If you add heads and legs to them, you'll get figures that, though very schematic, nevertheless express certain human characteristics.

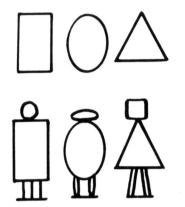

Don't think for a moment that you are doing something silly—you're not! You are simply starting from the beginning of all beginnings, not unlike our artistic cave-dwelling ancestors. The difference is, of course, that we do not have to spend millenniums developing our skills. We have examples of great art before us and the experience of many artists to guide us. &❧ Interestingly enough, this kind of shape and gesture notation is close to drawing a still life.

Notice the differences in height and width in these three objects—just as in people! Imagine this still life as a group of people by adding different heads to them. The result may look ridiculous, but disregard that—you're on the right track.

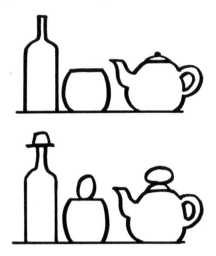

Another good visual exercise that helps in dealing with human figures is sketching trees. Trees, as has often been noticed, do resemble people with raised arms. Sketch trees, paying attention to the thickness of their trunks and the angles of branches. Hold your pencil vertically to see how much a tree leans.

Trees do not grow at even distances one from another unless they are planted that way, and they often overlap. So do objects in still lifes, and so do people on the street. Train your eye to notice these overlappings in your sketches. Make notations from life or from memory and put them down on paper with pencil, pen, or brush.

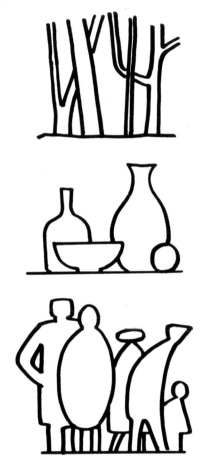

All these guiding principles are very much on my mind and at the tip of my pen when I'm sketching people.

A SIMPLE FIGURE COMPOSITION When you're ready to compose with figures, start simply. For this demonstration I arranged a few brightly colored objects on a patterned tablecloth and seated the model in a chair beside the table. Placing him there made him seem like part of the still life—an animate extension of it, perhaps. The schematic drawings at the beginning of this chapter relate particularly well to this setup. ❧ The composition consists of several geometrical elements including a square (the canvas leaning against the table), an oval (a plate seen in perspective), a cylinder (coffee pot), and a sphere (fruit). Strong directional energies are provided by the model's spread arms and crossed legs. And the colors are bright and contrasting. As a whole, this mixture of still life and figure, of geometric and dynamic details, is really quite similar to a multifigure composition in the problem it poses: how to get all the elements to interrelate so the painting can succeed. ❧ Even when composing a painting with a single figure in it, I first create rough geometrical shapes to represent him and, step by step, turn them into a human being.

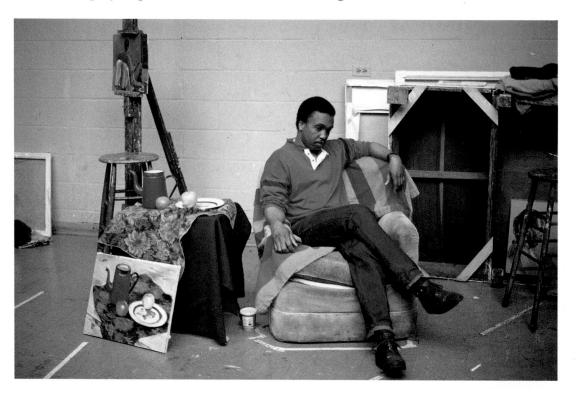

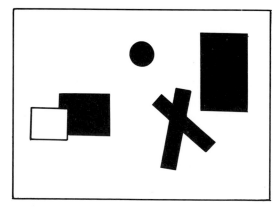 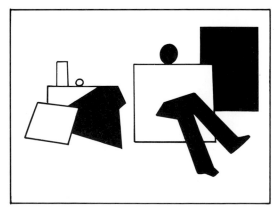

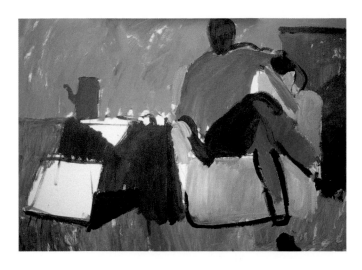

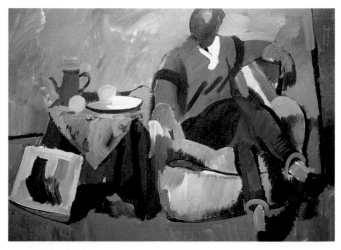

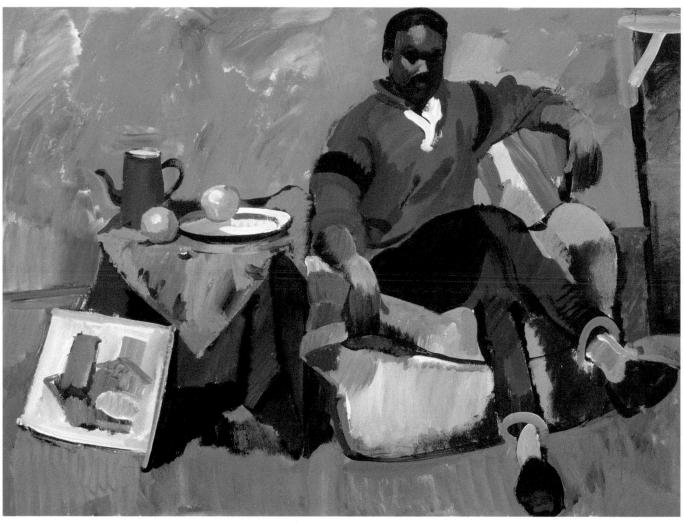

COMPOSING A BEACH SCENE

Believing that it is healthy to switch from small to large and back to small compositions, I do just that, often working simultaneously on one or two small paintings and on one large one. The beach, the park, and the street are recurrent themes in my work. They seem to me to express the human condition most vividly: seminudity on the beach (timeless, classical, and animalistic), relaxation and abandon on the green, and concentration, energy, and separateness, often loneliness, in the city. Earlier in the book I showed examples of the park theme; let me now turn to the beach, first to a small painting.

 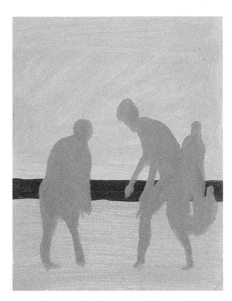 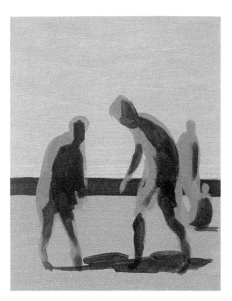

Sky, water, and sand are the main background elements of the beach scene. I have divided the board into three stripes to represent each, making them of different width and value. Once this is established, I indicate shapes of figures (remember my little schematic figure notations) in one basic color. Then come dark shadows. This is the underpainting, the skeleton of my composition.

I had in mind the image of a couple putting down a blanket and rendered the figures by memory, thanks to many hours of sketching at the beach. Sometimes a quick look at some of my drawings is enough to strengthen such a memory.

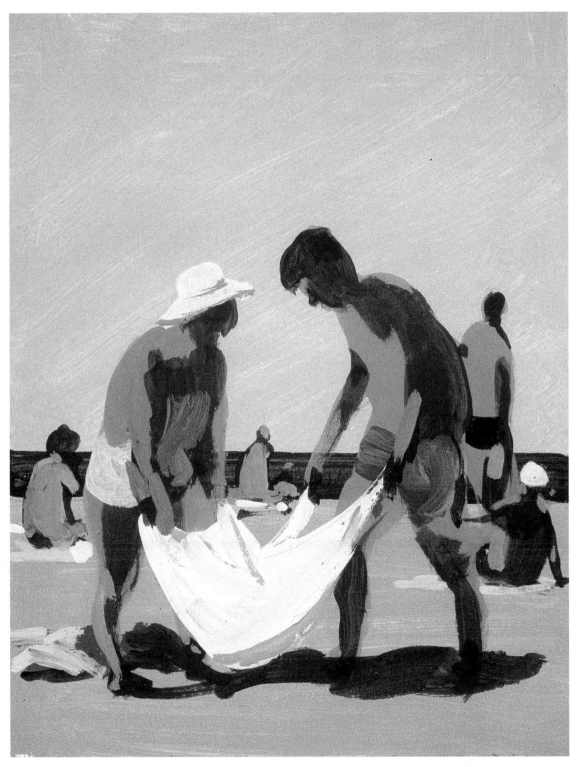

The next stage—adding details, highlights, and small figures—goes fast on a small-size board.

COMPOSING A BEACH SCENE

Afterward comes analysis, and the verdict is often negative: not interesting enough, too obvious, too posed. In other words, not worth saving. This thought is liberating.

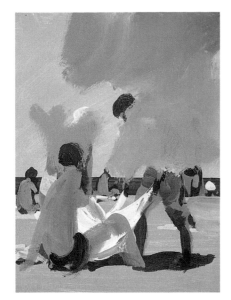

Without hesitation I paint out both figures, darken the sky, and create a sitting figure on the left.

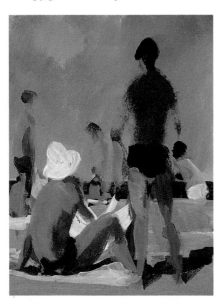

It looks better and I continue, painting a white blanket beneath the figure on the left and giving him a large white hat. To balance the angularity of the sitting figure, I create a tall standing figure and add other figures in the background. The standing figure has arms dangling. Is this good? Shouldn't he do something? Does the composition require more angular gestures?

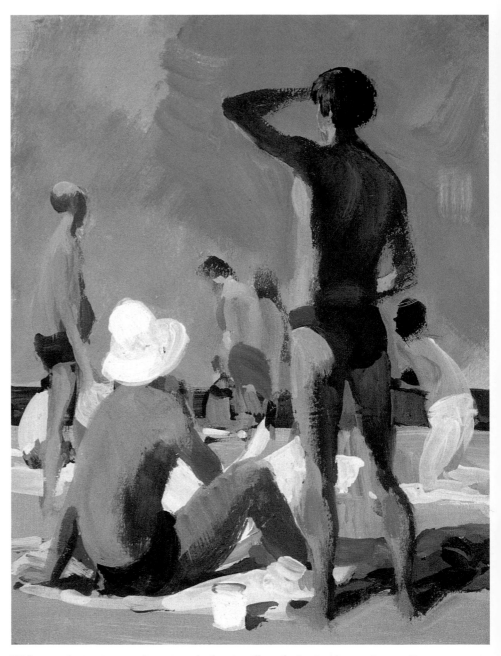

With some hesitation, not knowing whether it will work, I raise the man's arm. It seems all right. Then come further additions: I change the color of the man's swim trunks and paint some cloths on the ground. These seem to work and I keep painting, making details more definite, adding and changing some of them. For instance, the standing figure at the left becomes an older man, bald and with a little pot belly, and the main standing man gets more hair. I paint in a white water jug in front, some more white blankets in the background. Things seem to fall into place. Yet a nagging thought prevails: Is this all that can be done with a beach scene? There is such a variety of human shapes, gestures, and colors on the beach. It is a microcosm of humanity—organic shapes at the source of all life, water. Did I express it? Obviously not. Perhaps, I reason with myself, it calls for a larger size. But that will have to wait. I decide to let the small beach scene remain as it is—a sketch, no more, a little stiff, a bit monotonous in flesh tones, too rough to be anatomically convincing. But I tell myself to do better in a larger painting.

FINAL ANALYSIS It is my habit to follow up compositional ideas or to analyze my corrections by going back to the first stages. The standing man in the little composition opposite originally had his arms down. I didn't like it and raised one arm in the final version. But were dangling arms really so bad? Of course not, I just couldn't do them better in my small sketch. So later I made a larger painting in which I again explored the possibilities of a standing figure, one that would be more flexible and graceful. The result was *Bather*. Here the male figure assumes a classical position, supporting his weight on one leg with left hip up, right hip down, and shoulders tilting in the opposite direction. I thought this painting was better and abandoned the beach theme for a while.

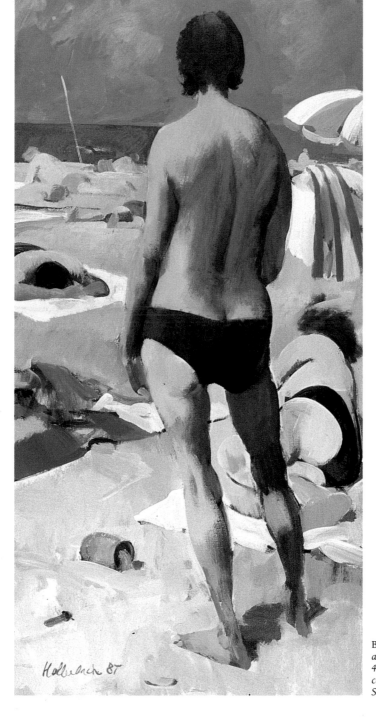

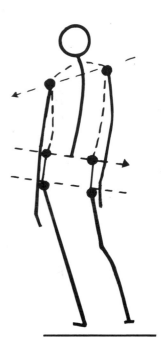

BATHER
acrylic on illustration board,
40″ × 20″ (101.6 cm × 50.8 cm),
courtesy Newman &
Saunders Galleries

COMPOSING STREET SCENES
No matter how much time a city dweller spends in the country, on beaches, or in forests, the city is always present in his or her mind as an essence, a concentrate of human activities. Being a city dweller I paint street scenes as often as anything else. Just as I do when working on other themes, I alternate the sizes of my paintings and do a lot of changing and manipulating in composition.

Step One. *Underpainting in two basic colors.*

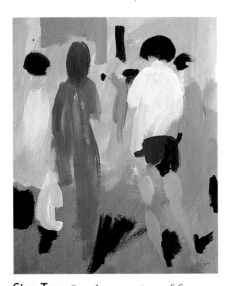

Step Two. *Rough suggestions of figures.*

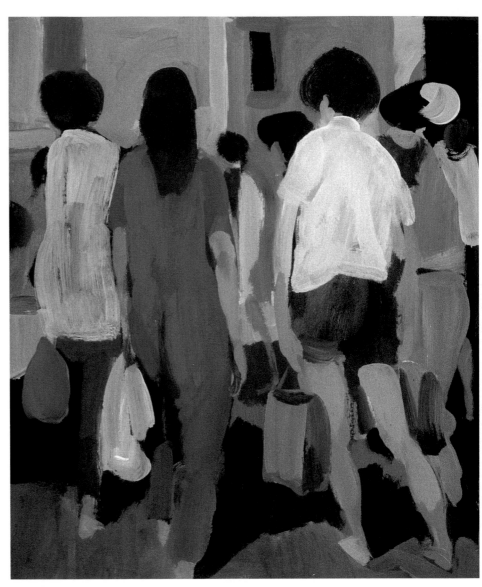

Step Three. *Completion of the figures. Verticals form the skeleton of this composition; two figures in the foreground balance each other, as do light and dark areas of shirts and dresses. Notice the very dark, slanting shadows on the ground; these anchor the figures and create diagonals that are needed to make the verticals less monotonous.*

Step Four. *Even so, I saw that all the figures were still too similar—all verticals and all back views. So I went over the whole thing. As someone once said, "Destruction is a form of creation." It is also a good practice to overcome the fear of ruining something you have created. Even if you ruin it (as I have many of my paintings), the attempt is worth making. Here I painted out the figure in red and suggested a bent figure—notice the dark curved line—thinking possibly of a woman pushing a baby stroller. I also added bluish shadows on the back of the figure in the white shirt.*

Step Five. *But then it occurred to me that another thin-legged figure, even bent, will not solve the problem. How about a big figure in red walking toward us? With a few brushstrokes this possibility is explored.*

Step Six. *At this point, I see that my color sketch looks worse than before. It is a messy crowd. But then, messy crowds are inspiring, for they cry for balance and order—and you can order them around. I decided to enlarge the figure in red, change the length of her blouse, and make her carry a brown bag. Her bent arm breaks the monotony of all the verticals— the arms and legs of the other figures. This figure's head should be different from the others. I tried different shapes and colors but wasn't satisfied, so rather than keep on trying, I left the figure in search of a head for a while. All of a sudden I noticed that the figure in the white blouse walked awkwardly, dragging one leg behind. Yes, these sudden revelations happen often in my work. How come I didn't notice it before? Immediately I changed the leg and placed a child in the space at right.*

Step Seven. *Experience tells me that working all around a painting, abandoning and coming back to its different parts, is a good practice. So I continued to leave the figure headless and worked on the red blouse and on the sky and figures in the background, defining, adding, and eliminating some details. And then I went back to the headless woman. After at least six or seven tries (that's when you really appreciate quick-drying acrylic colors!) I settled on a head with long, light blond hair. It seemed to project properly. Doing the features again took some time. No matter what I did, this girl's eyes didn't look right; either they seemed too small or too large, or had a peculiar expression—a definite expression, that is, of curiosity, anger, or suspicion that was in conflict with the mood of the whole painting. After all, most people on the street have a vacant look. At last I came up with the idea of sunglasses, which created a neutral expression that finally looked right.*

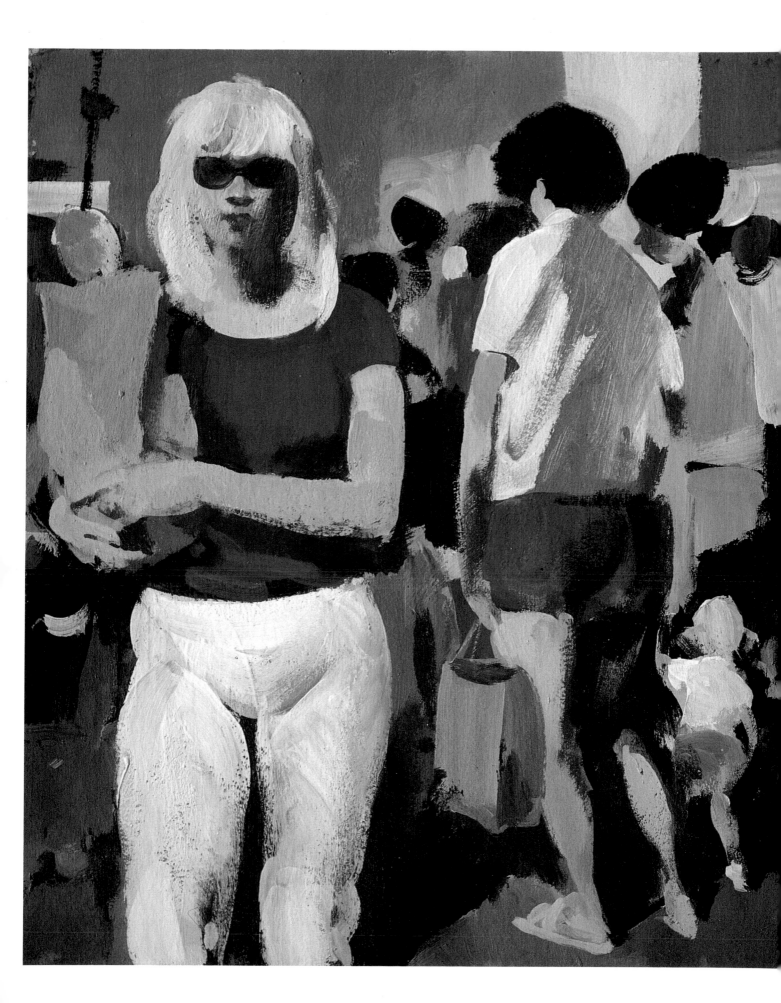

COMPOSING STREET SCENES

A repeat performance of sorts can be seen in *Woman in White and Two Others*; here the figure's eyes exist only as dark sockets. As the four step-by-step illustrations show, the woman started with a bent arm and held a white coffee container, but later I straightened the arm and let her carry a shopping bag instead. ❧ Having struggled with it in this and another painting, let me tell you that painting a white dress isn't easy, not for me at least. The shape of the body should be visible beneath thin white fabric. The woman depicted in this painting was actually young and slender; only her bosom provided the opportunity for shadows. The torso, no matter what I did, remained flat and shapeless. In despair I started to rub in strong shadows. The result was that the woman began to look pregnant. I pondered whether this was justified; it wasn't, after all, what I had intended. But I decided that as she turned out, the woman looked strong enough to carry her bag *and* the child realistically, so I let well enough alone.

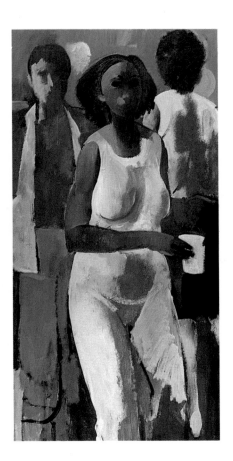 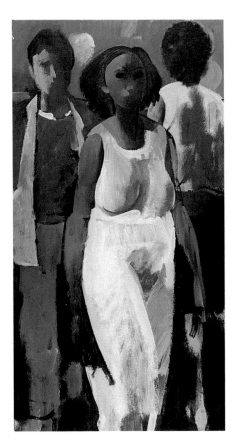 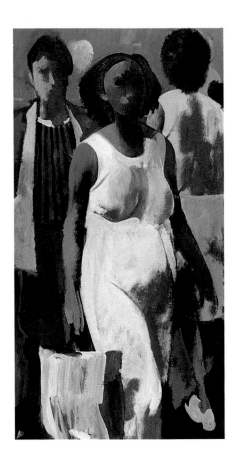

WOMAN IN WHITE AND TWO OTHERS
acrylic on illustration board,
40″ × 20″ (101.6 cm × 50.8 cm),
courtesy Newman & Saunders Galleries

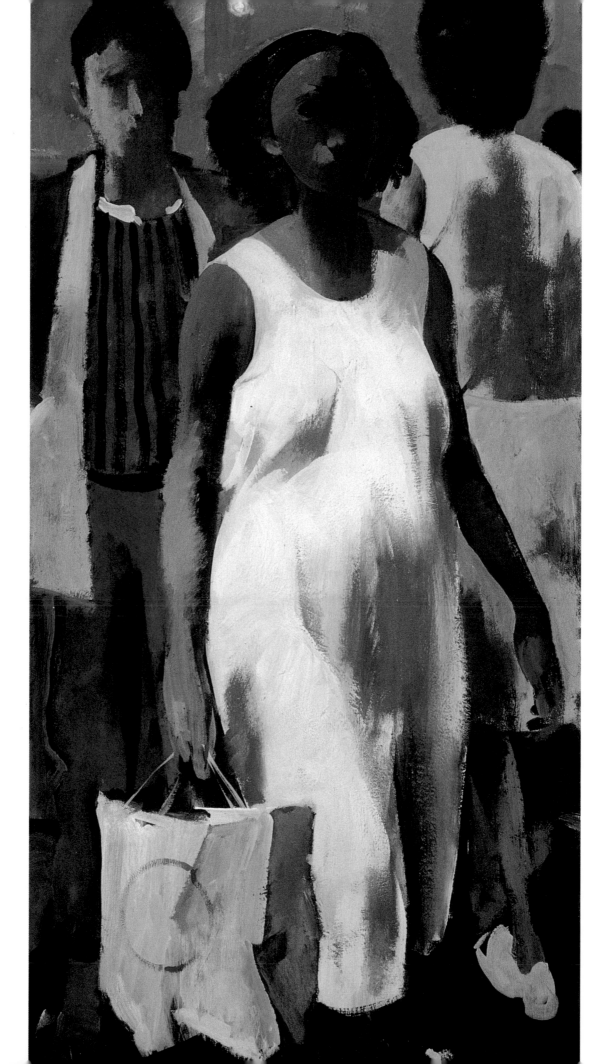

AVOIDING COLLISIONS On numerous occasions while doing street scenes, I have discovered that some of my figures stand on each other's toes, bump one another with knees and elbows, or squeeze someone into the wall—all unintentionally, of course, by oversight on the artist's part. This should always be corrected. 𝕃 In *Rush Hour* and *Rainy Day* I took great pains to avoid the problem of colliding figures. Even so, both compositions are rather tightly packed and on the verge of being physically impossible.

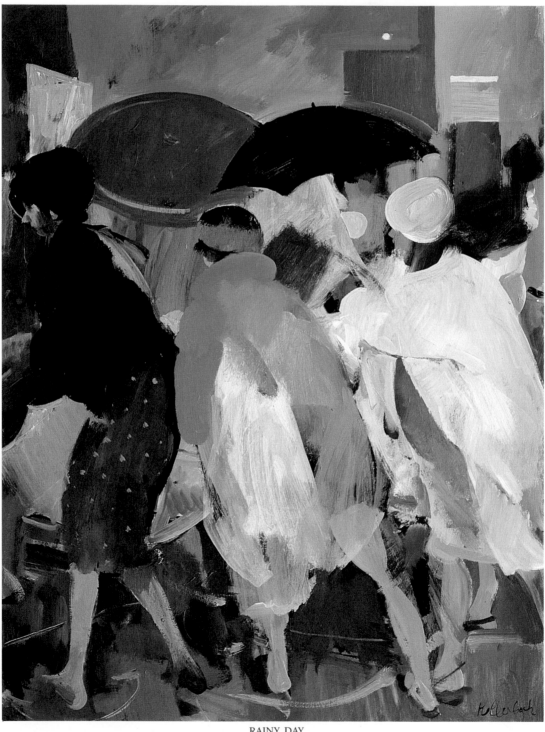

RAINY DAY
acrylic on illustration board,
40″ × 30″ (101.6 cm × 76.2 cm),
collection of Mrs. Elizabeth Hooper

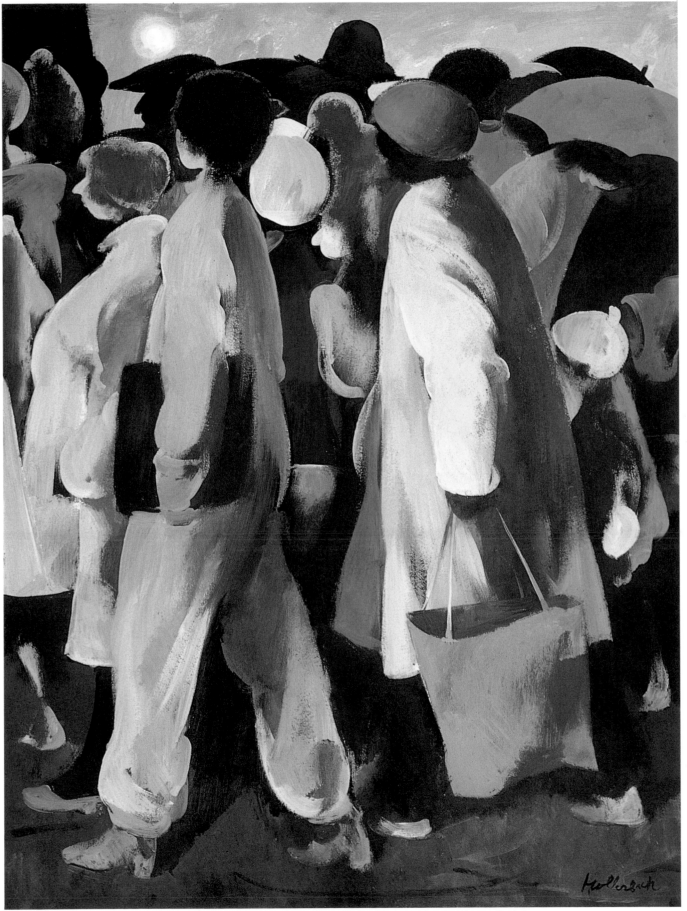

RUSH HOUR, *acrylic on canvas*, 40″ × 30″ *(101.6 cm × 76.2 cm)*, *private collection*

AVOIDING COLLISIONS

To avoid collisions and other compositional problems, sometimes you can deliberately separate figures. On the street people often walk one next to another without crowding. In *Three Figures with a Dog* you see just that. Starting with an almost abstract design, creating verticals and diagonals, then developing human shapes out of them, I ended up with an evenly spaced composition. To give it variety, I painted the clothing on the three women in basic colors of red, blue, and white. An outstretched arm pulling the dog's leash also helps to make the scene more dynamic. Notice that the eyes of these three women are again just dark shades, giving them a self-absorbed and remote expression that doesn't distract the viewer from experiencing the figures as a whole.

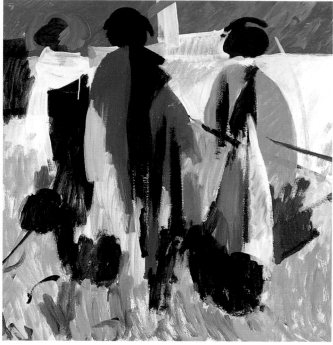

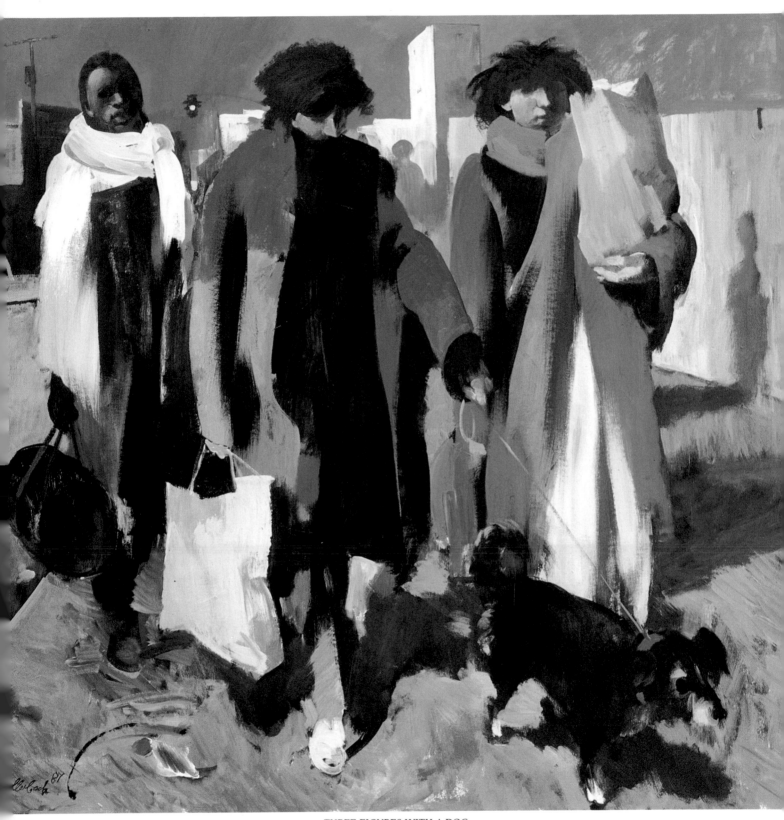

THREE FIGURES WITH A DOG
acrylic on illustration board,
40″ × 40″ (101.6 cm × 101.6 cm),
courtesy Newman & Saunders Galleries

EVOLVING A FIGURE PAINTING Fall, winter, spring—then suddenly summer days are upon us, and inevitably an artist's attention is drawn to beach and park scenes again. Having done a number of beach scenes with reclining figures, I decided to try one with some action in it. "Beach Frolics," as I wanted to call it, ended up being a picture that took more time and underwent more changes than almost any other painting I have ever done, and to this day represents one of my major efforts. I would like to show in several step-by-step illustrations just how this painting evolved and how I arrived at the final version. 🙚 I began by looking through some of my sketches and watercolors, not to find a pose, since I rarely transplant a figure from a sketchbook to a board or canvas, but to find a general impression, a mood.

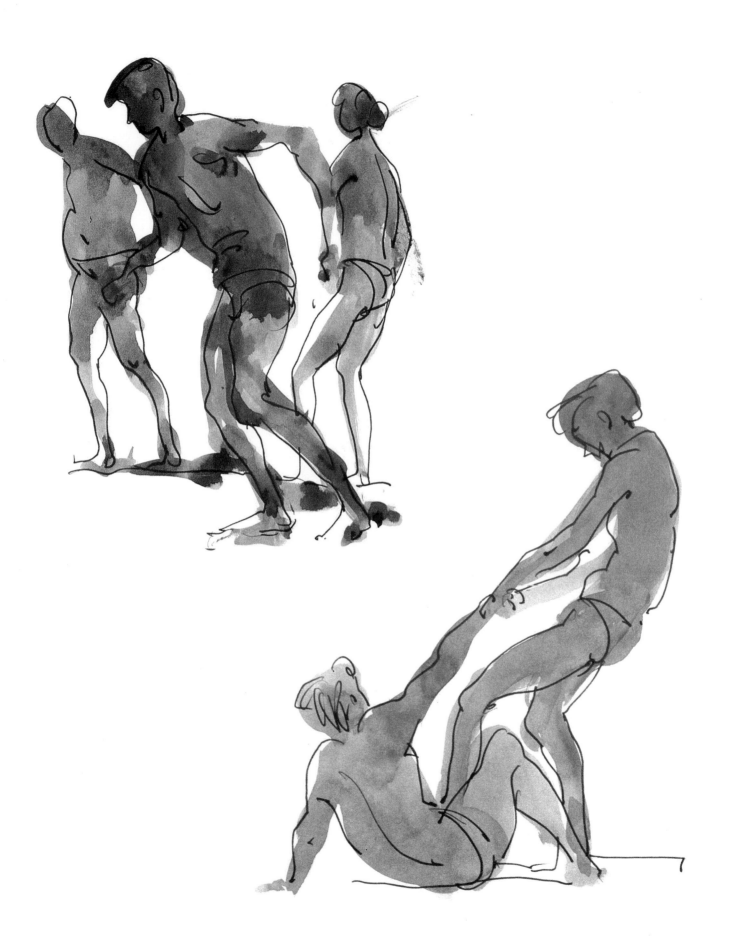

Dark figure silhouettes have always attracted me, and in a few days I put together a painting with a young man and a woman against a ground of light sand and dark blue sky, with smaller figures scattered around. The young man's gesture came easily, but the figure of the girl he is pulling gave me trouble. Finally I settled for a rather passive type who reluctantly allows the man to drag her toward the water.

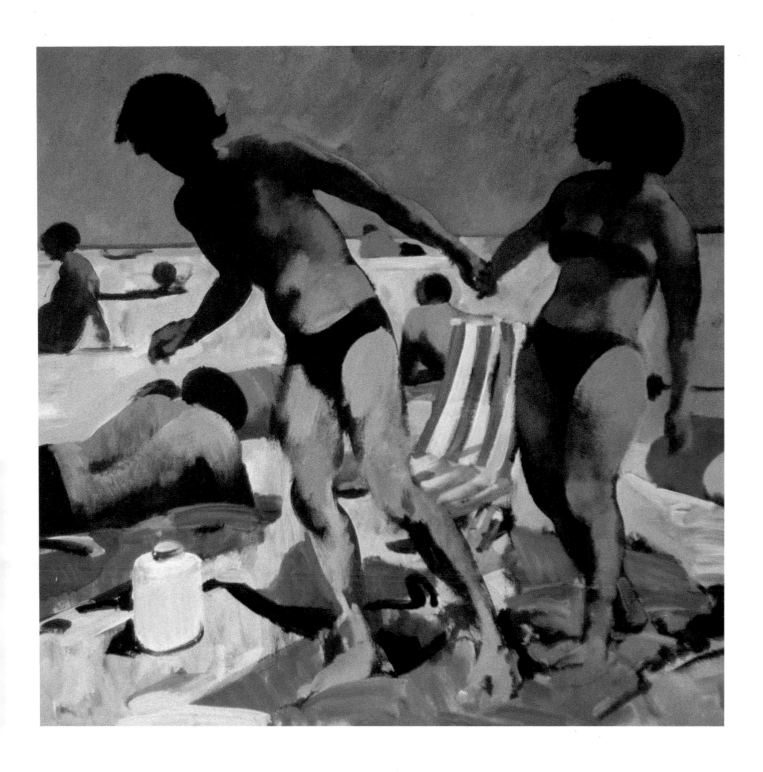

EVOLVING A FIGURE PAINTING

As soon as I finished the composition, I realized that it looked posed, unrealistic. And there is little frolicking in it. Some details seemed to be all right—the man's legs, for instance. Still, the main characters had to go. It takes a bit of courage to destroy large figures (it's almost as if you kill them), but cowardice has no place in art. First, the girl was eliminated and replaced with a sitting female figure that is lighter in color and more massive in shape. Immediately the man pulling her up became even more posed, and I started to paint him out. There is something magical in this disappearing act. First goes the torso . . . then the whole upper part of the body . . . and finally, the legs. With the man gone, the beach became less crowded and new possibilities opened up.

EVOLVING A FIGURE PAINTING

Usually I take short breaks to analyze what I have done, a habit acquired through years of teaching. A discrepancy between the size of the large female figure on the right and other smaller figures in the distance became apparent to me. To compensate, I decided it would be good to enlarge the man lying on his stomach, so I turned him on his side, had one arm support his head, and let the face and chest go dark, thus retrieving some of the dark harmonies of the original two figures. For a light center of interest I quickly sketched a small child in a white hat. To make the woman's outstretched arm do something, I painted a white cloth—perhaps the child's shirt or a small towel—for her to hold up. All these changes came in rapid succession within an hour and a half. Only acrylics permit changes like these, because the surface never becomes muddy or messy, and extensive scraping off of paint is unnecessary.

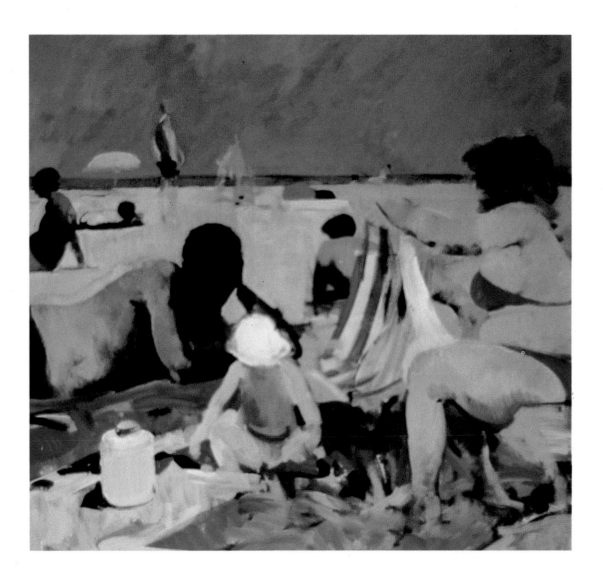

After another break and more analysis of every figure in the composition, this is what I found: a) The reclining man needs a face and . . . a navel! b) The child needs a face too. I couldn't come up with a good one and therefore lowered the hat, obscuring the face. A cop-out? Yes! c) The woman needs a face, another arm, and another leg. The cloth in her hands should be more defined. d) The child needs pants. I tried red and discarded it as too close to the color of the sand. So I settled for blue. e) Some order must be brought to the orange cloth in the foreground, but without losing the freshness of the brushstrokes. I flattened out the orange cloth somewhat and put a small yellow cup on it to push things forward. As final adjustments I added dark maroon stripes on the mother's chair to balance the dark figure of the man. Their upward movement further counteracted the directional energy of the man's body and the slanting position of the orange cloth. I made the mother's body a little paler, in better contrast with the sand; I also gave more definition to her hair, worked out the figures in the background, and painted a few white clouds in the sky.

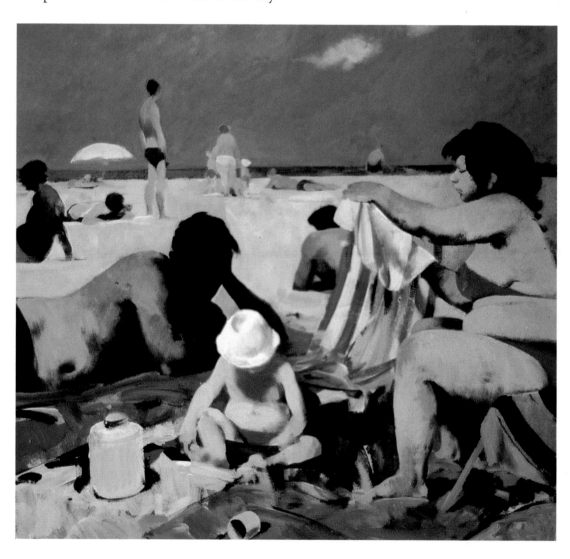

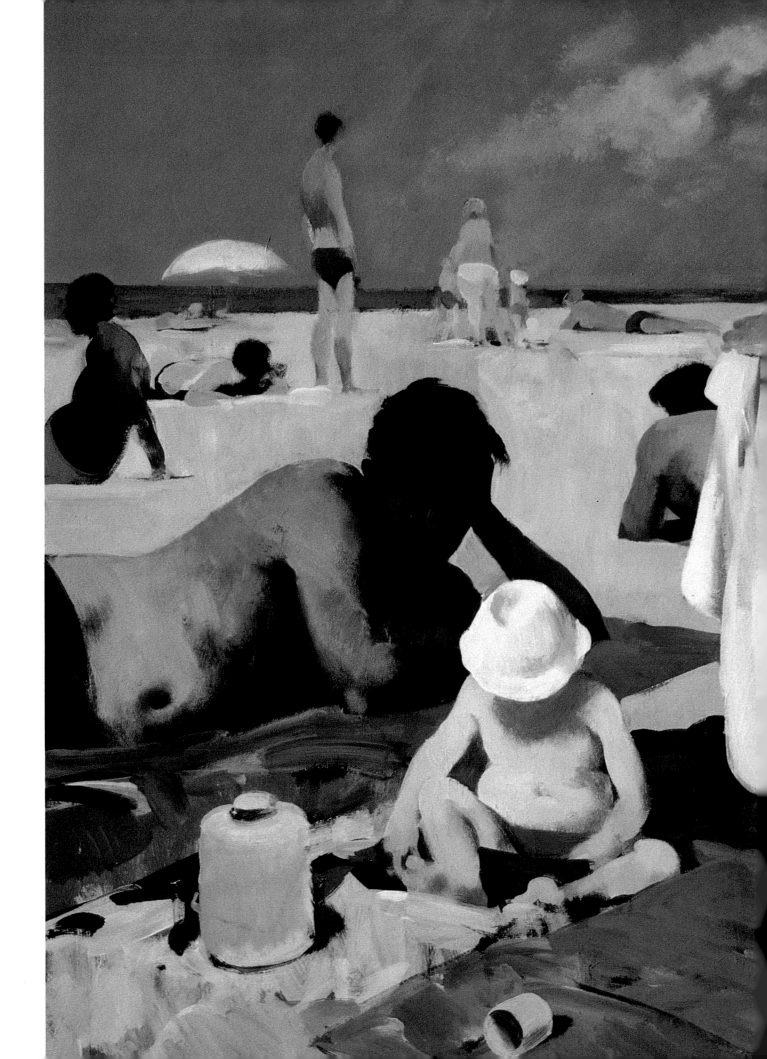

EVOLVING A FIGURE PAINTING

I considered this painting to be almost finished and hung it on the wall in my studio. It is a good practice to observe a painting this way for a few weeks, because sudden revelations occur; things you didn't see before become clear. A month and a half passed, during which time I was vacationing in France and painting landscapes. When I came back I saw that my *Family at the Beach*, as I decided to call it, while better than "Beach Frolics," still lacked the freedom, air, and space that make a painting easy to look at. Should I attempt a second partial destruction? If so, what has to go? Perhaps it would be better to start a new painting and leave this one alone. After some deliberation I started with small changes. The horizon line seemed to drop down on the left and had to be straightened out. In doing that I changed the color of the sky a little—it was too blue and I decided it would look better hazy. Finally I made a more drastic change. The stripes on the beach chair and on the cloth the mother holds looked much too busy. Why not a simple white cloth, I thought, and away with the chair? Then I added still more clouds in the sky. ❧ A day or two passed and I couldn't think of any more changes other than some major ones that would have resulted in a different picture altogether. So I stopped and signed the painting.

FAMILY AT THE BEACH
acrylic on illustration board,
40″ × 40″ (101.6 cm × 101.6 cm),
courtesy Newman & Saunders Galleries

RETHINKING FAVORITE THEMES These two paintings represent attempts to further explore the compositional possibilities in subjects I return to time and again. It's especially refreshing to do this after a long, involved struggle with a painting like the one on the preceding page. *Sunbathers* is another in my "Shrimp on a bed of lettuce" series. I tried strong shadows on the reclining figures and added a little more "mayonnaise"—the white towels—to see what would happen, but I'm not sure I have succeeded. In *Ocean Beach III* I aimed for fewer figures and a simpler, perhaps more relaxed composition than many of my other beach paintings have.

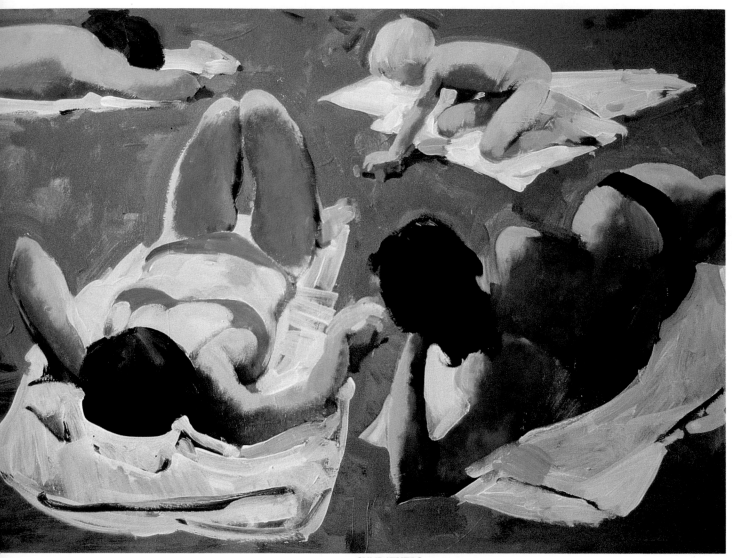

SUNBATHERS
acrylic on illustration board,
30" × 40" (76.2 cm × 101.6 cm),
courtesy Newman & Saunders Galleries

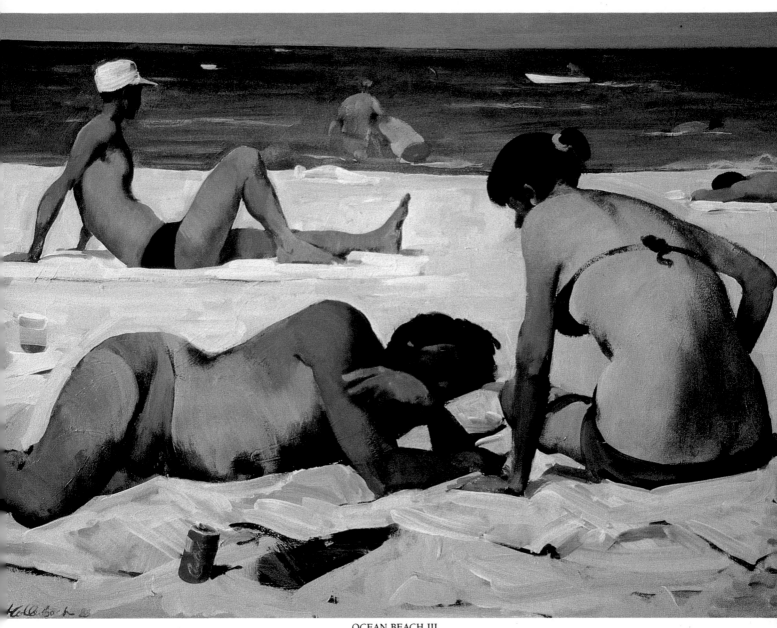

OCEAN BEACH III
acrylic on illustration board,
30" × 40" (76.2 cm × 101.6 cm),
courtesy Newman & Saunders Galleries

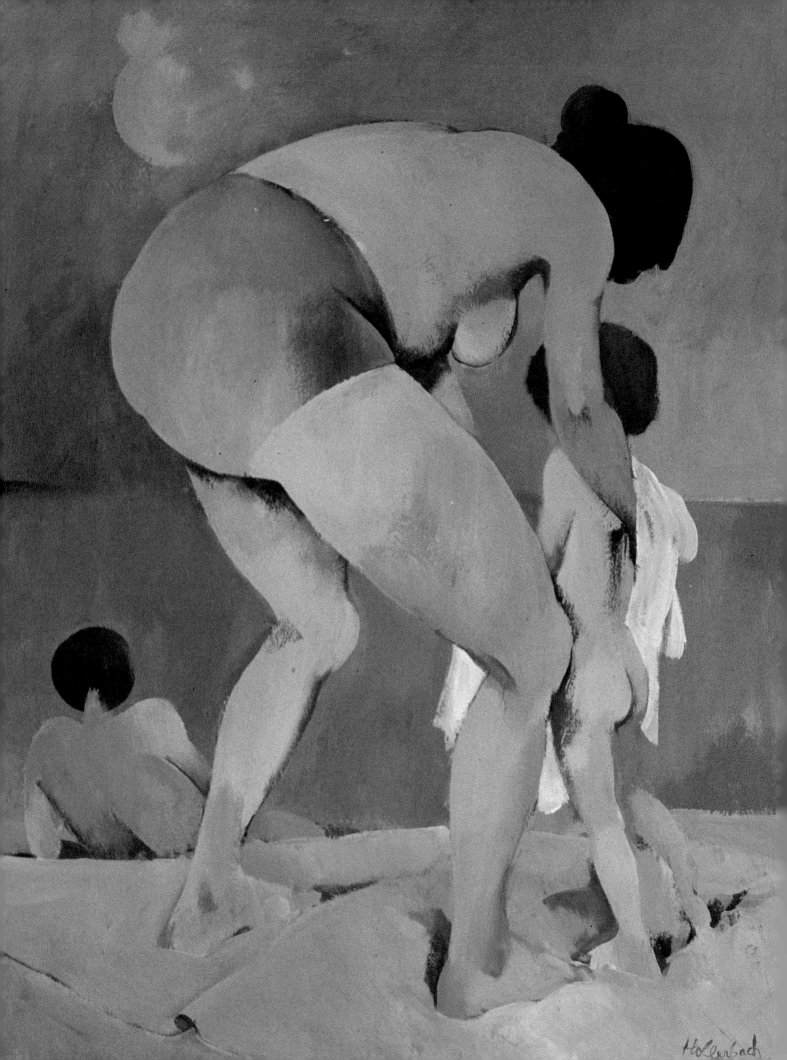

SOLVING LARGER COMPOSITIONS

Eventually you may want to attempt more ambitious compositions, perhaps larger paintings with numerous figures in them. You'll find that the bigger and more populated your pictures become, the more complex the problems they pose and the more inventive you have to be in devising solutions to them.

There is, of course, a physical aspect to painting bigger pieces. Abstract expressionists have often claimed that in spending the energy it takes to cover large surfaces, a painter becomes physically involved with his work in a way that creates the feeling of being one with it. For a figurative painter like me, however, a larger format offers not so much the physical pleasure of painting big, but the chance to work out a single idea on a somewhat grander scale.

As a means for expanding some of my favorite themes, I decided to explore the triptych format. While the sizes of the two compositions I present in this chapter are not really large by modern standards, painting them was like graduating from writing chamber music or short stories to creating a symphony or novel. Many painters, myself included, prefer to paint situations rather than narratives. I like to capture the general mood of a single moment and describe the character of each figure in it, and in so doing aim to give the whole composition a certain timeless validity. A triptych, however, allows you to take your subject beyond the boundaries of a single picture frame and introduces, just by virtue of its multiple components, a narrative element to a scene, or at least the illusion of it. Three panels are like three pages of a book; events described may or may not be directly related. When figures cross the boundary between one panel and the next as they do in *Riverside Park,* the feeling for me is that of looking out a window with panes dividing the view. Making the separate components of a multipart painting work together is a challenge, but it opens up further artistic possibilities. Everything has to be properly orchestrated—weighed, balanced, united yet kept diverse—so that the picture is easy to look at.

MOTHER AND CHILD AT THE BEACH
acrylic on illustration board, 40″ × 30″ (101.6 cm × 76.2 cm),
courtesy Newman & Saunders Galleries

THE FIRST TRIPTYCH In the chapter on composition I mentioned the "carpet effect," a scheme that calls for an overall placement of shapes in a picture, and gave my painting *Ocean Beach II* as an example. One day I happened to put a narrower painting of bathers next to it, and somehow they seemed to go together. So I made another one the same size to go on the other side, and a triptych was born, quite by accident. Here is how the entire work came about, piece by piece.

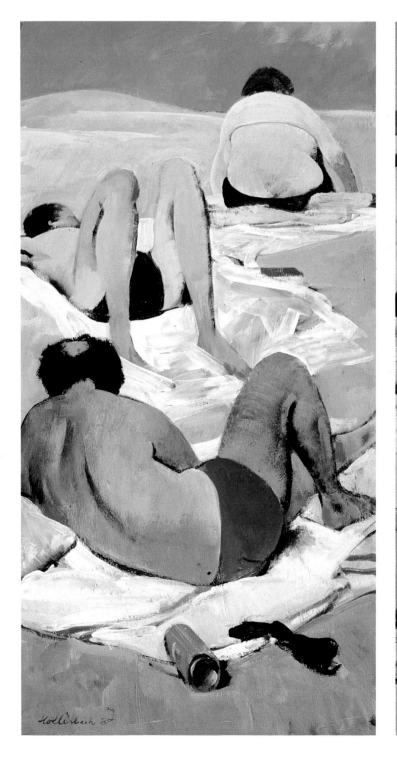

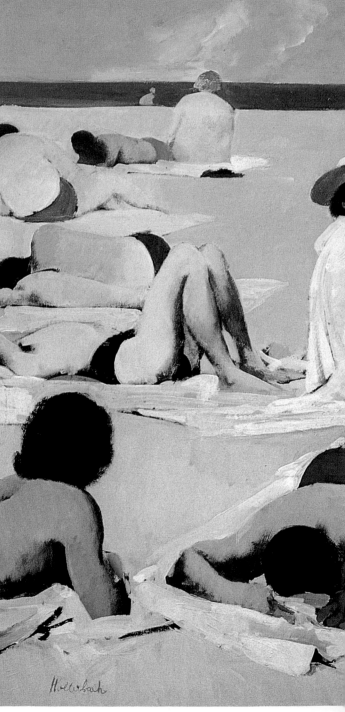

OCEAN BEACH II
triptych, acrylic on illustration board;
center panel, 40″ × 40″ (101.6 cm × 101.6 cm);
left and right panels, 40″ × 20″ (101.6 cm × 50.8 cm)

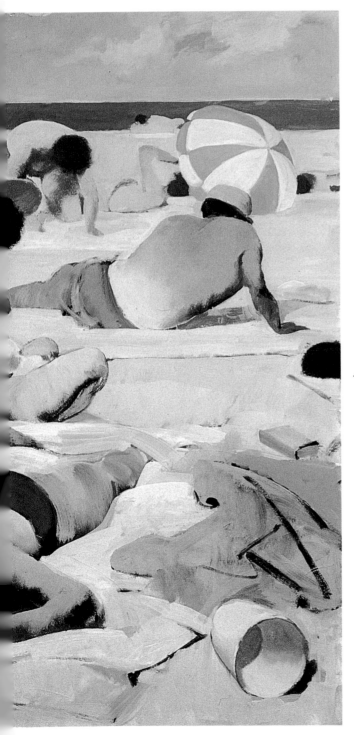

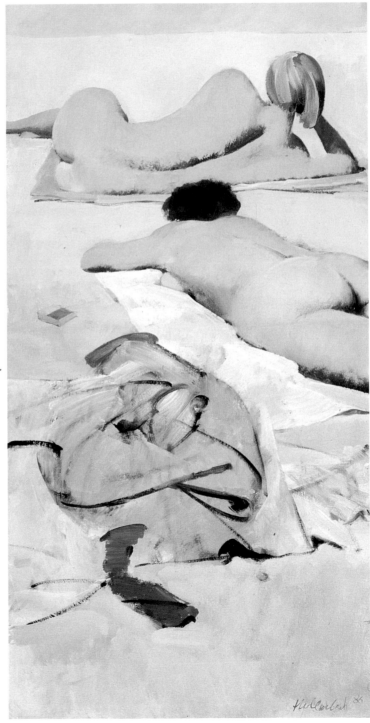

123

The Center Panel. *This section of the painting underwent many changes, all of them based on the principles of balance and directional energies. In the diagram, red X marks show figures or gestures that were eliminated; solid red shapes indicate changes and additions. In a sense, creating an overall composition is not unlike arranging a bouquet of flowers—you move and spread some, add green leaves to separate them, mix large with small, and so on. Just such back-and-forth adjustments took place in this painting. For instance, the umbrella in the upper right corner originally had red and white stripes; these seemed too bright and were changed to green and white instead. The heavyset man with his back toward us was once lying flat on his side, but seemed too similar to the figure on the left, so I made him support his weight with his right arm. Many small additions came later—the girl seated in the center, for example, was once seen with her face in profile and without the hat. The man lying flat on his stomach in the center foreground remained essentially the same as the painting progressed. The only trouble was with his legs. They just weren't right—too long, too short—and had to be moved around. His heels looked awkward and were painted over and over. At one point, while painting out the left heel, I thought that the brush-stroke looked like a fabric fold, so I let it cover the foot. A neat trick, but who would know different? The pail came as an afterthought.*

The Left Panel. *Both of the companion pieces had similar changes. In the left panel the large figure with his arm propping up his head seemed too static. After a few tries I ended up with a curved figure with one knee drawn up. The bald spot was an afterthought, as were the soda can and stray sock.*

The Right Panel. *In the right panel I had originally painted three figures, the same number as in the left panel. I painted out a male figure, replacing it with a heap of cloths. The figures' dark swimwear also looked similar to what appeared in the left panel, so I made the two women sunbathe in the nude instead. Why not? In other words, I design first; realistic justification comes later. You'll see that when everything is put together side by side for a final appraisal, it all seems to work reasonably well.*

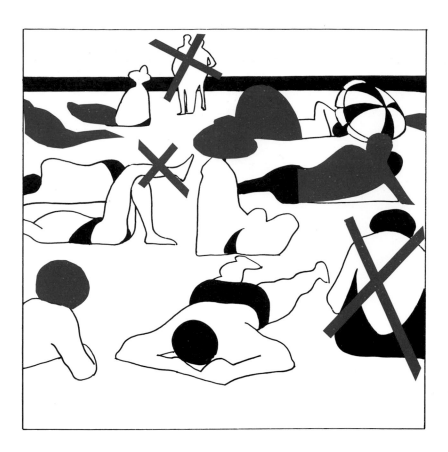

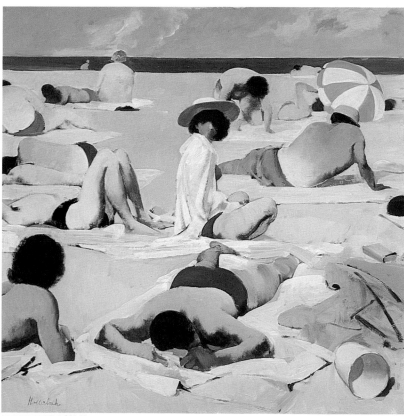

OCEAN BEACH II
center panel of triptych
collection of Dr. and Mrs. Charles Minehart

OCEAN BEACH II
left panel of triptych
courtesy Newman & Saunders Galleries

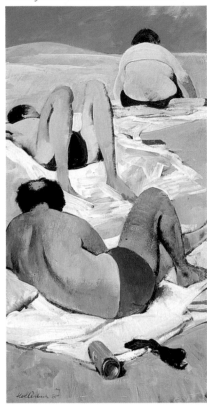

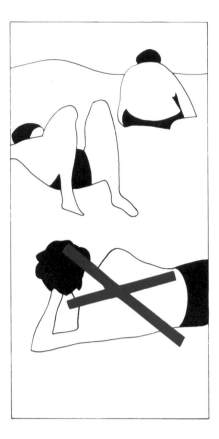

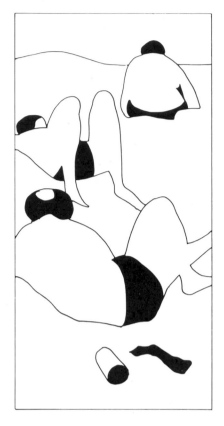

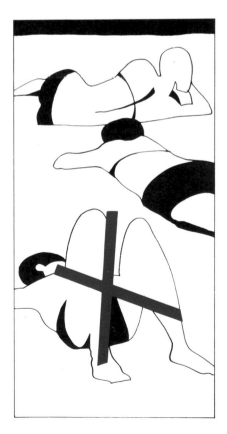

OCEAN BEACH II
right panel of triptych
courtesy Newman & Saunders Galleries

THE SECOND TRIPTYCH Once you
have gone through the process of matching three
paintings and discover you like it, you may get
hooked on triptychs and sooner or later will do
another one. I did, anyway. ⅏ The difference
between this triptych and *Ocean Beach II* is that
it consists not of three self-contained panels, but
of equal-size segments tied together by the
continuation of arms and legs over the bound-
aries of each picture frame. I planned it this way
and will exhibit all three paintings together as a
unit (whereas the components of *Ocean Beach II*
were each exhibited separately). ⅏ Is such
continuation across a frame a good thing? I don't
know. Some exhibition juries may find it too
clever; I have yet to see. But I do know artists
who have exhibited such works successfully.
One definite advantage is obvious—it's much
easier to transport three smaller pieces than one
large one; you don't even need a station wagon.
⅏ The theme was an old favorite of mine,
"Shrimp on a bed of lettuce"—that is, sun-
bathers in the park on green grass. What always
strikes me as being typical of sunbathers are
their gestures. Normally by this we mean the
motion of arms and hands. But out in the sun,
gestures include legs. When relaxing, people
throw their legs in all directions. This body
language was what I tried to capture. And
because when walking through a park we look
down at people lying on their towels or blankets,
I painted the composition as a bird's-eye view.
The leg gestures are very pronounced, and to
further emphasize them, I decided to use a
minimum of color in the figures' clothing, just
touches of brightness here and there. I decided
the dominant colors should be green, flesh
tones, and white.

RIVERSIDE PARK
acrylic on illustration board;
each panel, 40″ × 20″
(101.6 cm × 50.8 cm),
courtesy Newman & Saunders Galleries

126

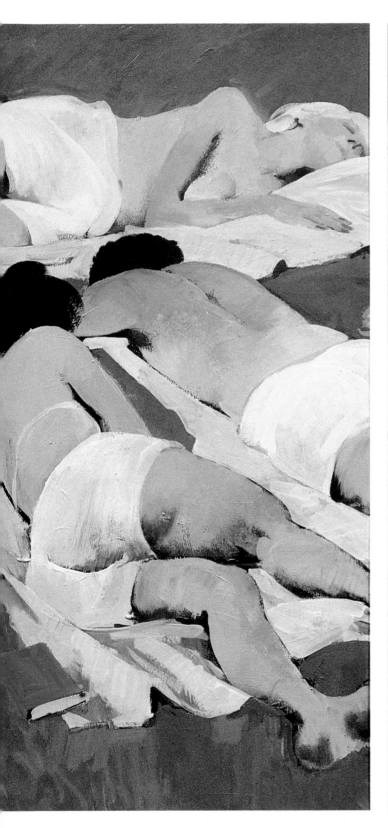

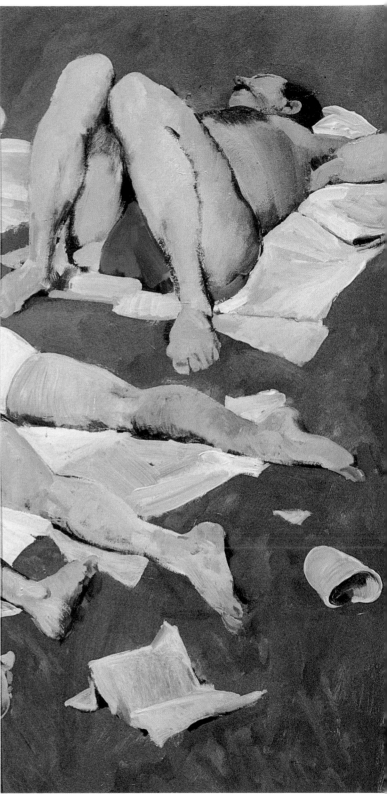

THE CENTER PANEL I began the center panel first, covering my illustration board with a solid chromium oxide green and a few patches of yellow ochre mixed in to represent grass. On top of this ground I used black to sketch in three figures, two lying diagonally, one horizontally. It's best to start simply like this. In the second step I added flesh tones. Keeping in mind that they should differ, I arbitrarily made the man darker and more suntanned. Next I added white for swim trunks and towels. Running parallel with the bodies as they naturally do, the towels reinforce diagonal energy lines. These initial stages took less than an hour. Then I spent a few hours of intensive work on the bodies, rounding shapes, rubbing in shadows and overlapping them with the flesh tones. Using gesso is especially helpful in such renderings, because it keeps the paint flowing without much thinning with water. I added a red book in the corner to pull the foreground more toward the viewer.

 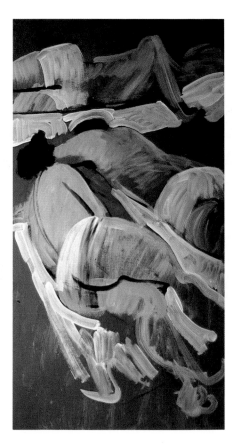

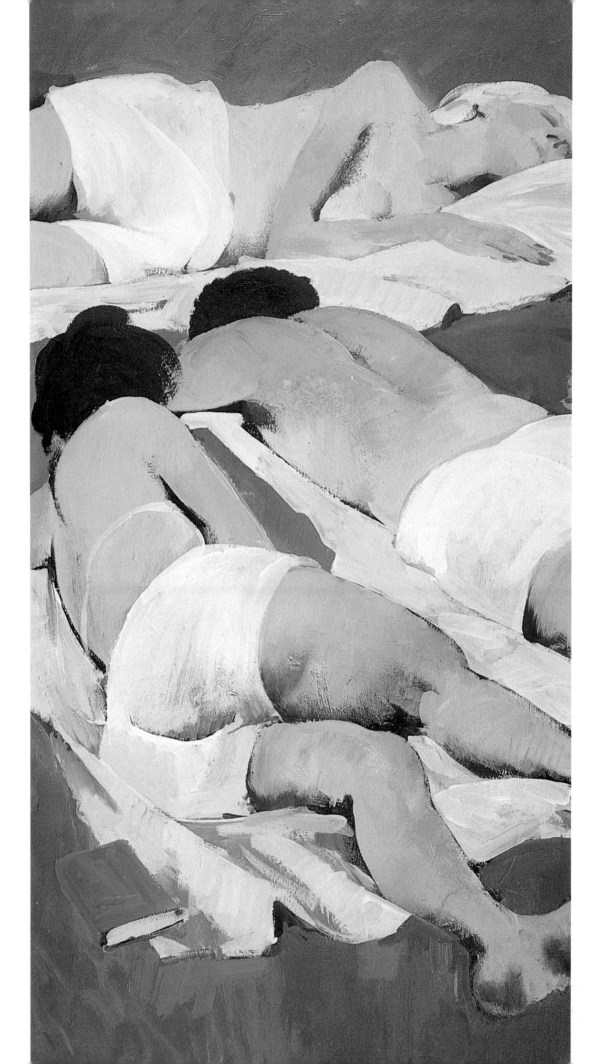

THE RIGHT PANEL After basically completing the center panel (there would be some changes later) I started on the right panel. At this point overall compositional questions came into play. How should I position figures in the right and left panels? Of course, they must balance and counteract those in the central panel. This diagram shows my thinking: The legs of the man and right foot of the woman will continue across the frame into the right panel. Some figure should descend from the upper right toward them at an angle. On the left panel another sunbather must prop up the central figures.

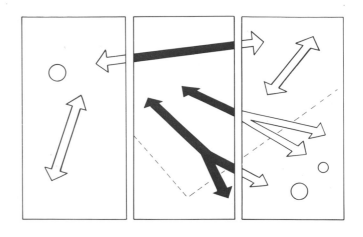

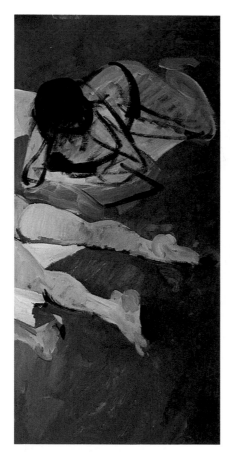

Covering another panel again with the same chromium oxide green, I extended the figures' legs from the central panel and sketched in a reclining female figure.

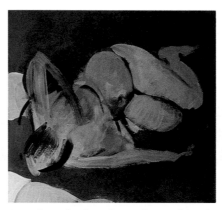

Something displeased me. Quite often it's hard to define such a feeling; I just wasn't encouraged to continue painting this figure. It wasn't enticing enough. An artist gets a signal that says something is going to work; I didn't receive that signal and so changed the pose.

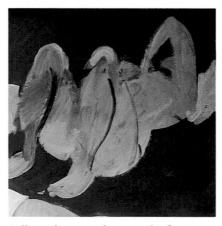

Still another try. This time the figure is lying on its back. A faint signal, at last!

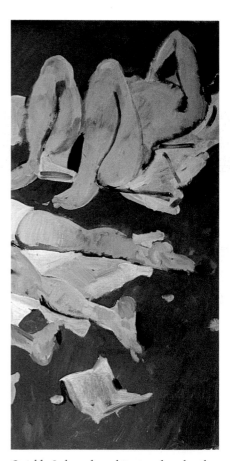

Quickly I shoved a white towel under the figure and added a few white shapes—perhaps a newspaper?—to break up the monotony of the green.

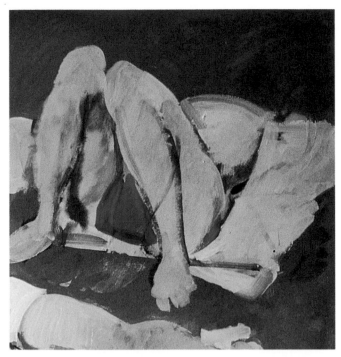

The figure's raised arm looked stiff and the drawn-up knees shouldn't be parallel. So I brought the knees together and changed the black shorts to red.

The figure, now a man (sex changes occur often in my paintings), has no arms and no head! Cautiously I made an outstretched arm grow and defined an armpit.

Now the face. I love foreshortenings, where you see the tip of the nose, an ear, and a shock of hair. Some shading on the ribcage was added too.

Design considerations told me that a dark spot was needed to separate body and arm, so I painted hair in the figure's armpit—a very realistic detail, as it turned out. Yet design was what determined this reality. But something was still missing. Through trial and error I came up with another dark shape—a patch of hair on the man's chest. That seemed to work well and I called the figure completed.

THE LEFT PANEL I set up the left and last panel next to the other two and began with the same green background, then sketched in a male figure and completed the rough underpainting of flesh tones. Next I extended details from two of the central panel figures into this picture frame: the legs of the woman at the top and the elbow of the one in front.

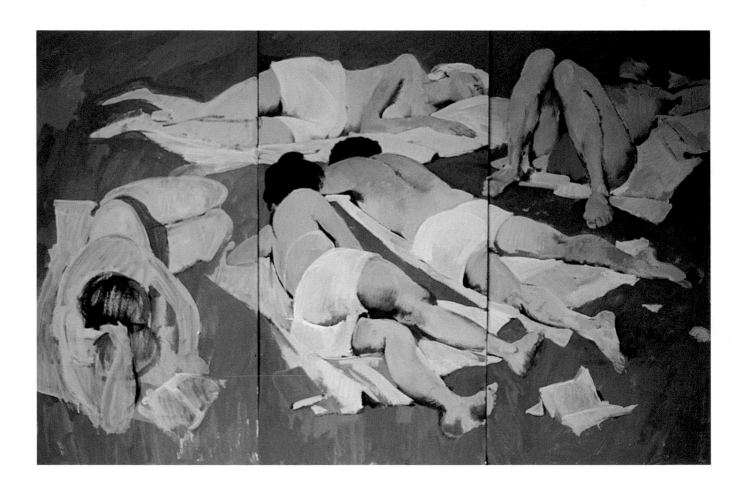

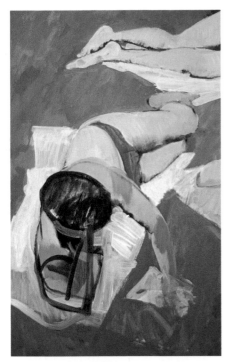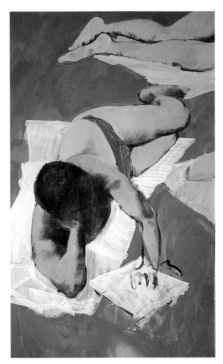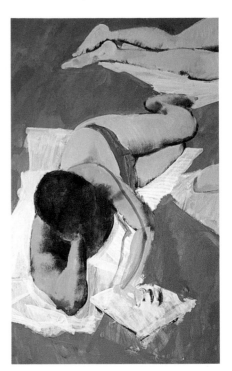

I continued to work on the reclining figure. There was something wrong with the arm on which the man's head rests, so I tried to correct it and searched for a good position for the other arm and the hand placed on the newspaper.

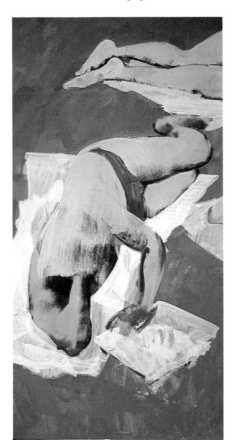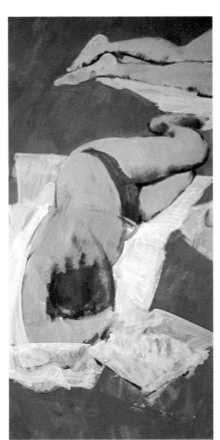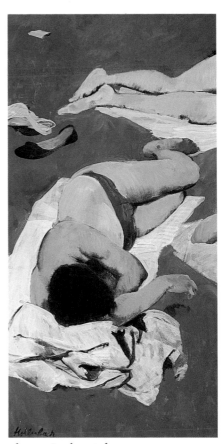

Nothing worked to my satisfaction. In desperation I painted out the head. Not only was I exhausted, so was my man—his head fell down on the bent arm. And suddenly a strong signal told me this was going to work! I extended his bent arm, made the other arm grow back, and painted a pile of white cloth under his head. Then I put in a few additional touches, placing a pair of shoes near the girl's feet to break up the emptiness of the upper left corner.

ANALYSIS AND REVISION It was then time to look at all three panels together. After quickly making the small addition of a paper cup on the right panel, I let the painting stand for a number of days so I could make a critical appraisal of the whole composition. A work like this one has to sink in so that it can be judged in detail.

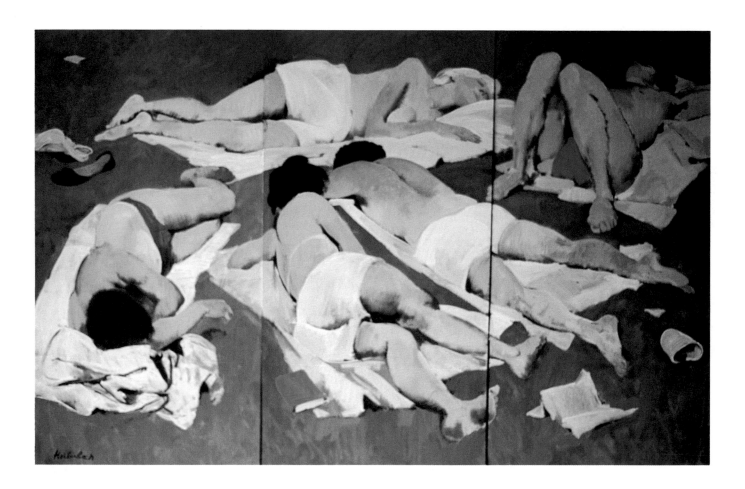

The result of this appraisal was that I began to dislike the figure of the man with the hairy chest. It attracted too much attention, distracting the viewer from the central figures. Could I do something else with this one? The only way to find out was to paint over the head, chest, and arm; I left the knees intact, since they seemed to be all right. Perhaps less face and an arm placed on the chest would work out? The answer was no. Would a raised elbow be better? No! Angrily, I painted out the arm. There was an accumulation of thick paint in this spot, and the new layer had to dry a little—it happens even in acrylics sometimes. An idea occurred to me, a straw hat. How does it look? I didn't receive any signals, negative or positive, and the hat stayed on.

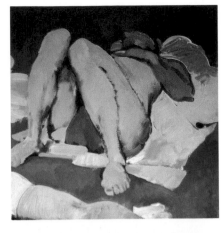
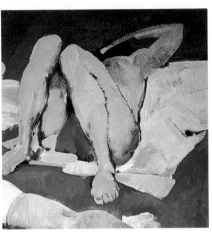
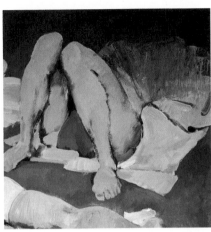
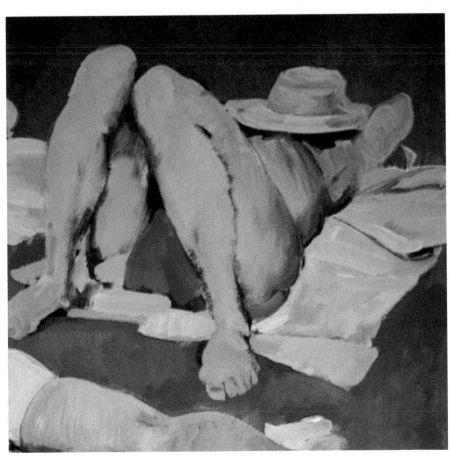

Is the triptych finished? An inner voice tells me, Not yet. There is something in hiding, unseen, that will provide an unpleasant surprise later. What is it?

❧ Again I let some time pass. One day I made a shocking discovery: It is the woman in the foreground of the center panel. Her right leg is too short, and it's stiff and clumsy. And—oh, horrors—her left leg is even worse! From knee to foot it is very long, with a ridiculously short thigh. And how could I fail to have seen that the narrow green strip that separates the man's body from the woman's is so stiff! Of course, it emphasizes the stretch of their bodies, but wouldn't it look better if it was broken by the woman's bent knee? Or fabric? I began to make changes on both legs. ❧ The pose became even more clumsy. Quickly I retreated to the previous position, but with a slight difference: I made the woman's too-short left thigh longer and bent the right leg a little. Thus the legs were rescued—or so I hoped.

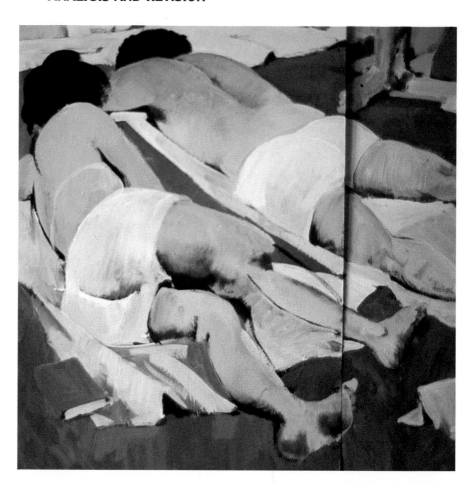

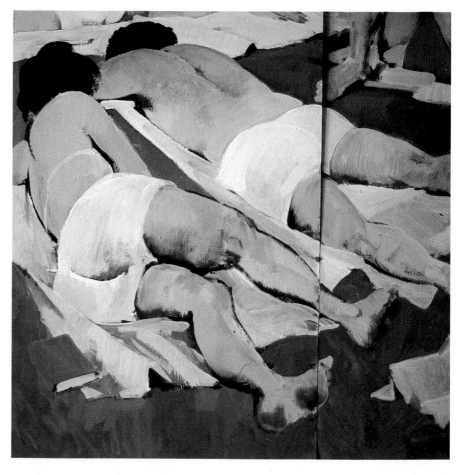

A few more days passed and the straw hat covering the face of the man in the right panel started to annoy me. Its presence detracted from the central figures as much as, if not more than, what was there before. So I made another retreat, bringing back the man's face and hairy chest with some modifications. 🐦 By this time, I must confess, my will to experiment had diminished, so I signed the painting. It will hang on the wall of my studio for some time before I show it; in doing this I follow the advice of Henri Matisse, who believed that artists should wait at least six months before showing their work to the public. Who knows what one may discover in a supposedly finished composition? 🐦 A word about signatures: As we all know, these reveal some inkling of our character. Sloppily scribbled or tightly lettered, with fancy swirls or elegant brush-strokes, a signature on a painting says something about the artist. But signatures are also part of the painting. They should integrate with it, not only in placement and weight, but also in color and character. I have had to change some of my signatures several times because they seemed to make my painting too busy, or they filled space that looked better without it, or because I thoughtlessly grabbed a color that was too harsh. Modesty is a virtue in signing a painting. However, I consider not signing a painting to be the other extreme; it's like saying "Let them guess who painted this good picture."

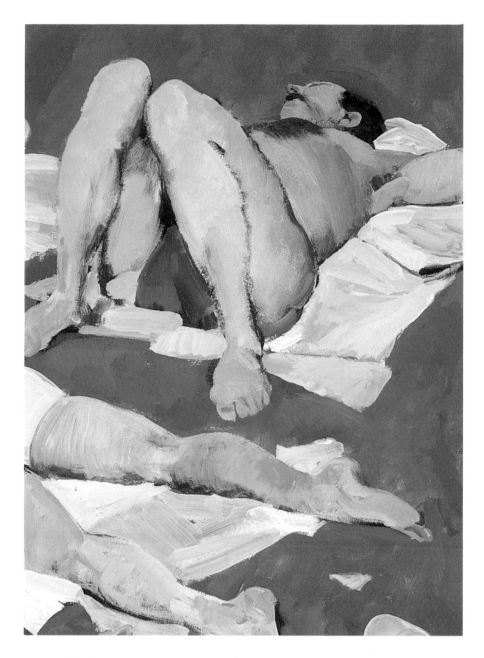

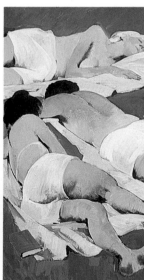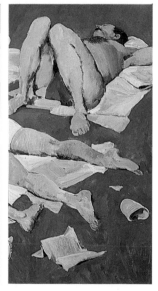

137

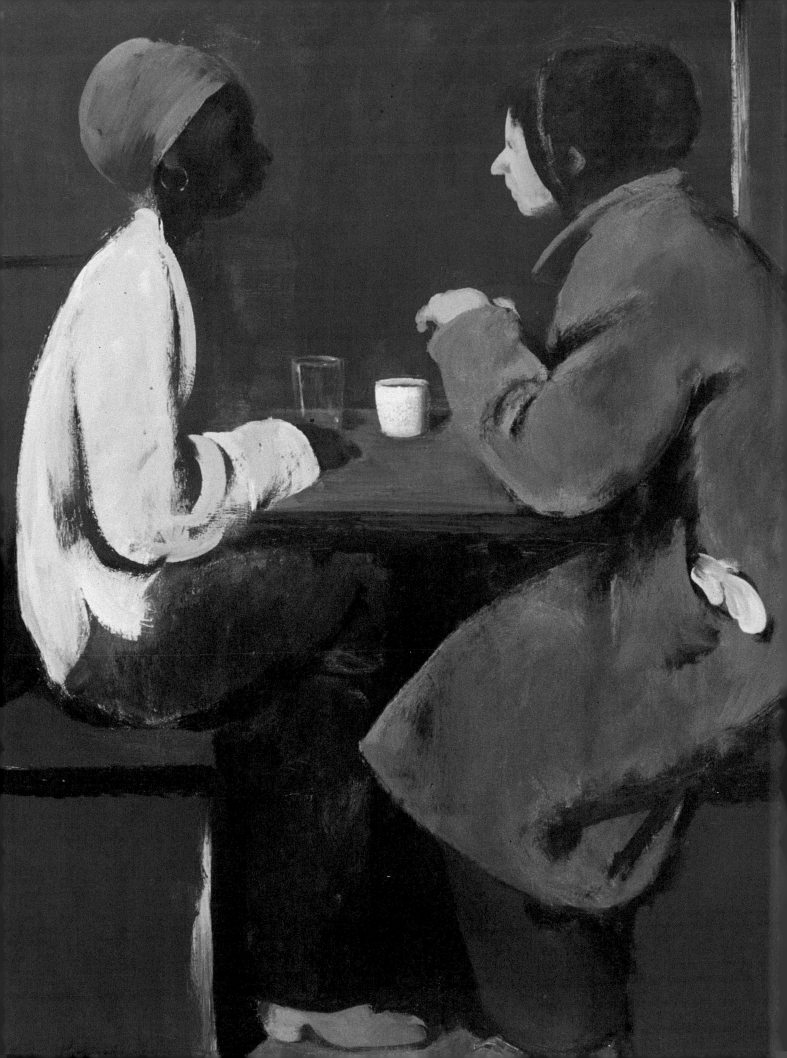

EPILOGUE

Our artistic preferences—the particular colors we love, shapes we choose, contrasts and harmonies we find pleasing—are deeply rooted in our psyches. It is really hard to say why some people hate green but love purple, why others prefer orange or red to blue. In choosing furniture, some people are excited by ornate period styles, others by simple modern designs. Our upbringing may help form our taste and character, but it is not fully or directly responsible for who we become. Psychology speaks of our subconscious, about how we sublimate our desires, loves, and hostilities in the creative arts; and certainly we do this. But why we are this or that way is still a mystery and should remain so. Attempts to explain everything will only intellectualize art to the point that it becomes science. Art, however, is not science. ❧ Why all these observations? Because the study of painting is not just acquiring knowledge about the properties of colors and mediums, or about composition and the step-by-step development of a painting. It is learning about oneself. In finding out how far one can go in bright colors without becoming ridiculous, or how much form can be exaggerated before it loses its logic, or what has more meaning, realism or abstraction, an artist finds himself or herself not only as a painter and draftsman, but as a person, as an individual. Painting with a medium as fast and agreeable to exploratory changes as acrylics gives you added freedom in finding your artistic preferences—that is, in finding yourself. ❧ While writing this book I have, of course, been painting new figure compositions. Very often they were slightly different versions of ones I'd already done. A follow-up, a repeat performance is important for an artist psychologically. It is a release, a letting go of oneself after a difficult job is done. Sometimes such bold ventures succeed and a new variation is better than a carefully thought out composition that has been analyzed and corrected many times. Sometimes they are dismal failures. Often they can barely be distinguished from the original version. But no matter what, when results are no longer the goal, you can experience the sheer joy of experimentation. No better reason for painting exists.

TWO GIRLS
acrylic on illustration board, 40″ × 30″ (101.6 cm × 76.2 cm),
collection of The Lotos Club, New York City

EPILOGUE

To conclude, here is a never-ending painting; the stages shown represent more than six months of work, off and on, and for a long time I had no desire to finish it. I finally did go back to it, though, and suddenly *Mediterranean Bathers* ended and was even exhibited. But now I have another beach scene on my easel where bathers come and go, dress and undress, just as in paintings before them, and we coexist happily for a while at least. A strange objective, you may say. But it satisfies a certain psychological need to have a painting that lives with you, changes with you and is never completed and put aside—a "companion piece," if you will. The very act of painting is, after all, a continuous labor without end.

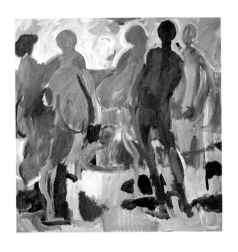 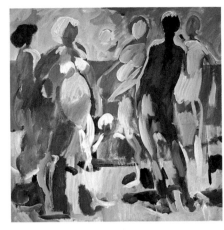 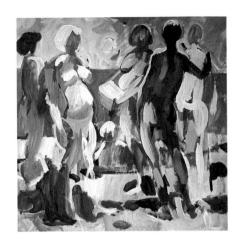

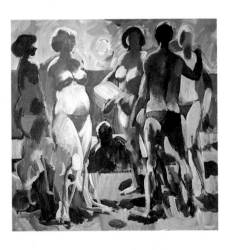 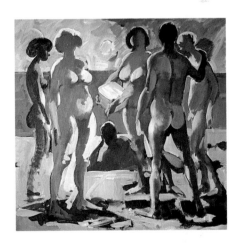 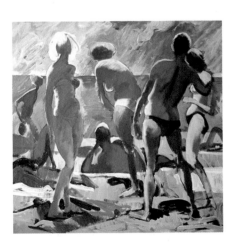

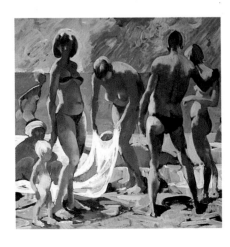 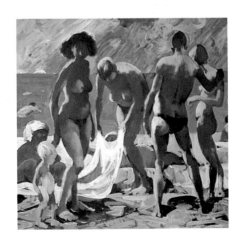 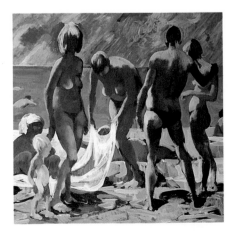

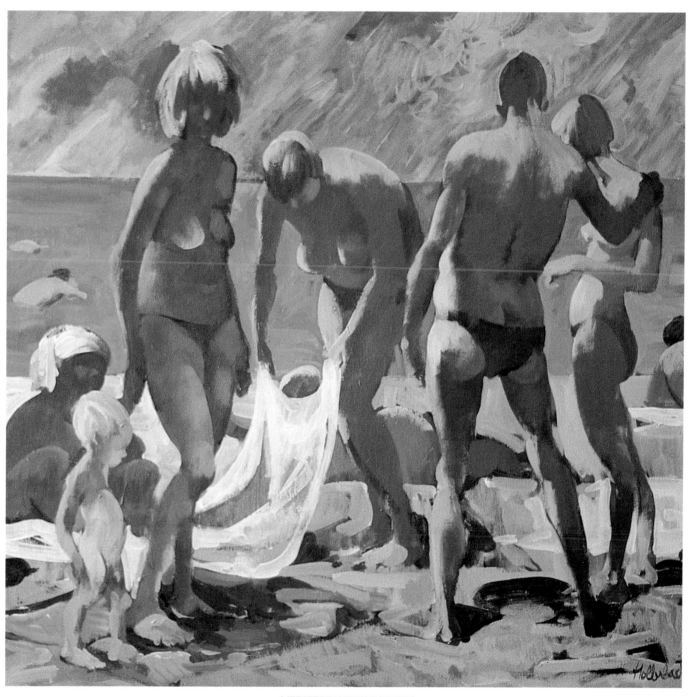

MEDITERRANEAN BATHERS
acrylic on canvas,
40" × 40" (101.6 cm × 101.6 cm),
courtesy Newman & Saunders Galleries

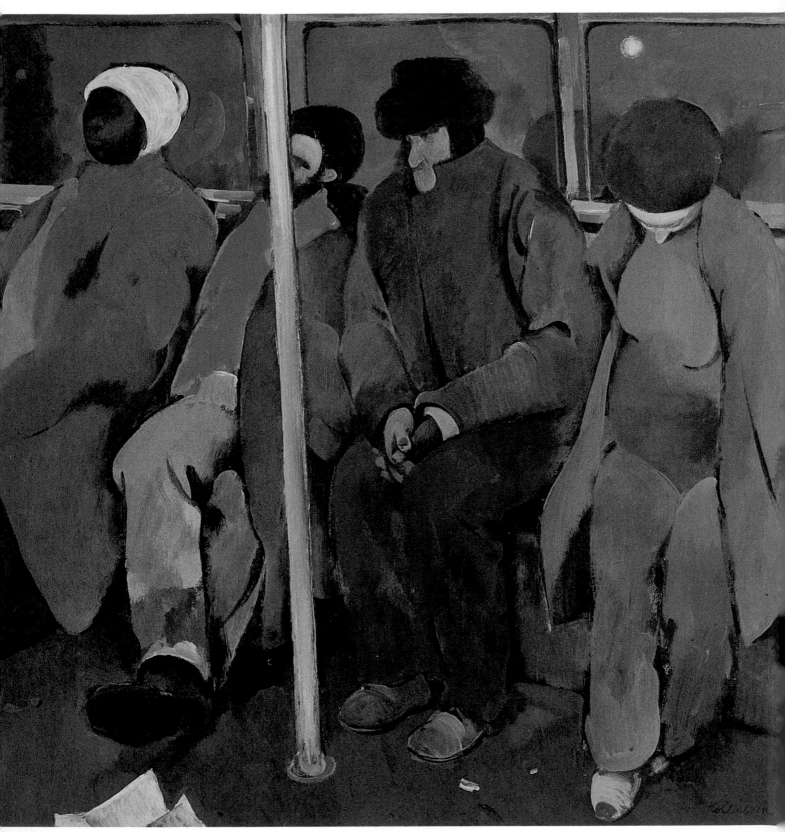

WEST SIDE IRT
acrylic on illustration board,
40″ × 40″ (101.6 cm × 101.6 cm),
private collection

INDEX

Edited by Marian Appellof
Designed by Bob Fillie
Graphic production by Ellen Greene
Text set in 12-point Berkeley Old Style